Oil Painting
with a
Basic Palette

Morgan Samuel Price

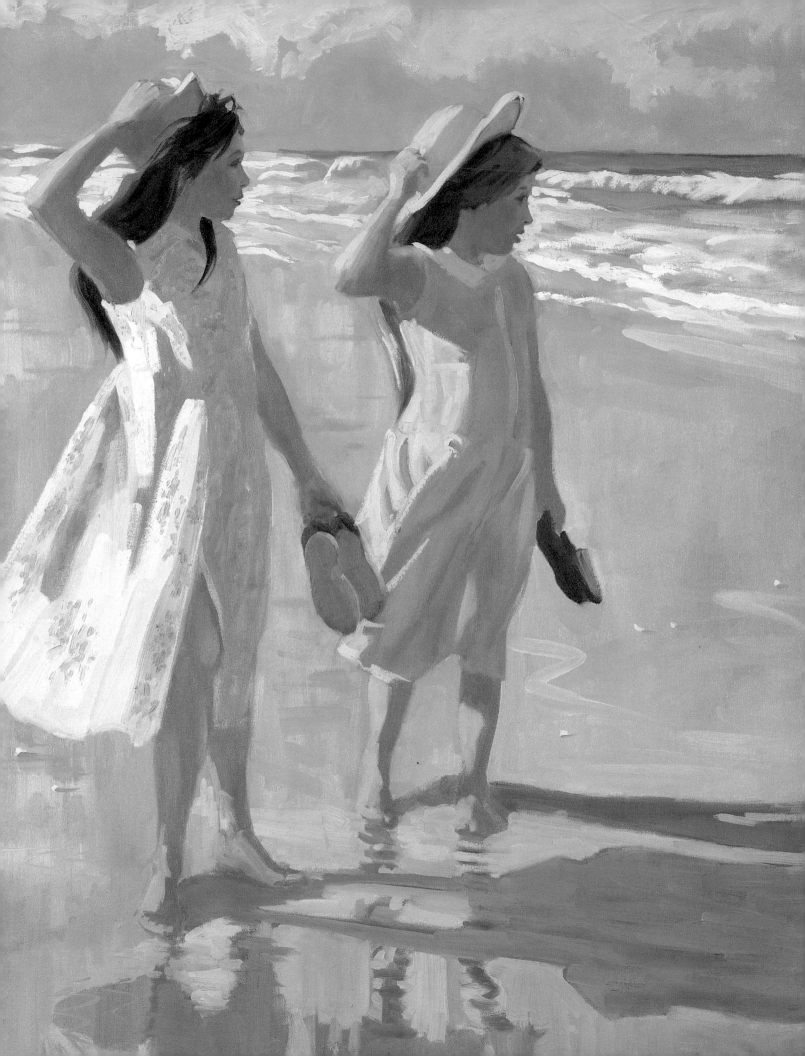

Oil Painting
with a
Basic Palette

Morgan Samuel Price

NORTH LIGHT BOOKS
CINCINNATI, OHIO

ARTIST'S BIO

Morgan Samuel Price is an elected member of the Allied Artists of America, the American Artists Professional League, the Salma-gundi Club, the Pastel Society of America and the Association Pour la Promotion du Patrimoine Artistique Francais.

She has received numerous awards during her years as an artist. Among them are the Winsor & Newton award for oil painting, the Joseph Hartley Memorial Award for oil painting, the Claude Parson Memorial Award for Landscape and the Leon Stacks Memorial Award for a Southern Artist. She was the designer of the United Nations Day posters for 1993, 1994, 1995 and 1996, and her works have appeared in the National Parks Calendar. She has been published in *American Artist* magazine, and she appears in *Who's Who in American Art* and *Who's Who International*.

Morgan Samuel Price has exhibited across the United States and in Scotland, England and France, and her works appear in collections in the United States, Canada, England, Scotland, France, Africa, India, Israel, Sri Lanka, Germany, Australia, Russia, Sweden, Lithuania, Poland, China, Japan, South Korea, Nepal, New Zealand, Jamaica, Ireland, Cyprus, Spain and Greece.

Oil Painting With a Basic Palette. Copyright © 1999 by Morgan Samuel Price. Manufactured in China. All rights reserved. No part of this book may be reproduced in any form or by any electronic or mechanical means including information storage and retrieval systems without permission in writing from the publisher, except by a reviewer, who may quote brief passages in a review. Published by North Light Books, an imprint of F&W Publications, Inc., 1507 Dana Avenue, Cincinnati, Ohio 45207. (800) 289-0963. First edition.

Other fine North Light Books are available from your local bookstore, art supply store or direct from the publisher.

03 02 01 00 99 5 4 3 2 1

Library of Congress Cataloging-in-Publication Data

Price, Morgan Samuel
 Oil painting with a basic palette / Morgan Samuel Price.—1st ed.
 p. cm.
 Includes index.
 ISBN 0-89134-882-4 (alk. paper)
 1. Painting—Technique. I. Title.
ND1500.P75 1999
751.45—dc21 98-31052
 CIP

Editor: Michael Berger
Production editors: Amy Jeynes and Michelle Howry
Production coordinator: Erin Boggs
Designer: Sandy Conopeotis Kent

ACKNOWLEDGMENTS

Many people have cared about my dreams and aspirations, and I thank them all. My learning has been stimulated by the sharing and generosity of others throughout my life. Right from the start my mother understood I was fascinated with art, and she nurtured my passion with unwavering support. She gave me the opportunity and the enthusiasm for art—two of the greatest gifts a child can receive. Even today she plays an important role in my career by assisting in the running of my studio.

I have counted on my family all along for encouragement and get it unfailingly. To my children, Connon, Michael and Morgan, my husband Ron, and my second family Ron Jr. and Steve, thank you for allowing me to find my way and for knowing that the journey continues. My work continues unhindered because of your loyalty and love.

There were four very remarkable people who have directly influenced my development as an artist and helped to shape my thinking. Eliot McMurrough was the first artist I had the pleasure of watching, and he lit a fire that is still burning brightly. Patricia Kirkberg, a highly gifted painter, shared her knowledge and introduced me to a range of mediums when I was taking my first tentative steps. Loren Wolford towered over my formative years in art school. His many lessons still linger in my thoughts. And to Carl Cogar, an inspirational teacher and a great friend, I am especially indebted. He has generously shared his vast knowledge for over twenty years. The lessons he taught and the generosity of his teaching still inspires me today.

The labor of writing this book fell on more shoulders than my own. I was greatly assisted by Terry Holmes, who helped me turn raw information into a logical flow of ideas and techniques. His professionalism and skill were much appreciated.

TABLE OF CONTENTS

Getting Started

Morgan Samuel Price leads you through choosing and using your equipment. Learn the differences between the various brushes and brush materials. See how to prepare your painting surfaces. Be introduced to Morgan's basic palette. And work with her through exercises designed to teach you how to effectively use your equipment.

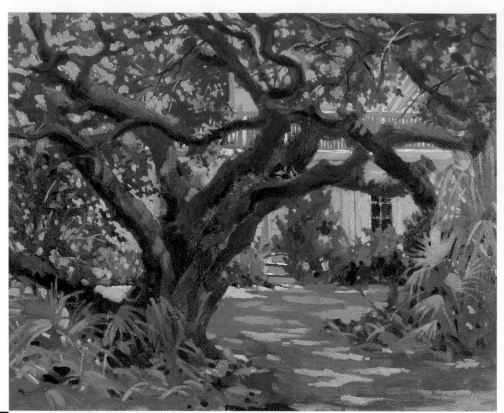

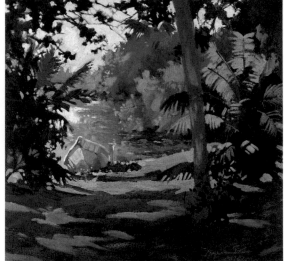

Use Value to Build Space and Form

Learn about the value scale and how to create your own. See how to use value to create space and form. You'll also learn how to train your eye to see value correctly, and exercises will teach you how to maintain consistency through simplifying your values.

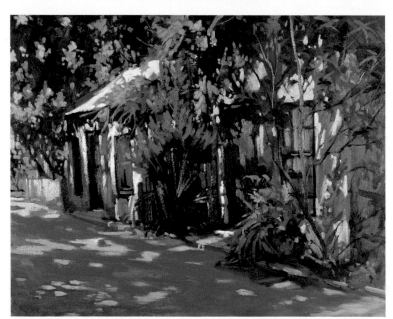

Elements of Color

Learn how you can use the primary, secondary and tertiary colors on the limited palette to create just about any color you need. Learn about the three key elements of value, intensity and temperature. See how light affects your composition, and learn the different kinds of light. Finally, Morgan will walk you through how to paint color and light effectively.

Design

Learn how to create effective major design elements. See the difference between positive and negative space. Learn about some common design flaws to avoid. Let Morgan lead you through the elements of perspective and how to use it effectively. And finally, a gallery of design notes will, show you how some of Morgan's paintings are broken down into their major components and how those components work together.

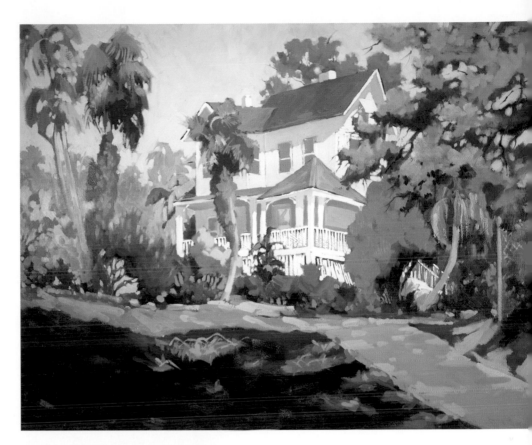

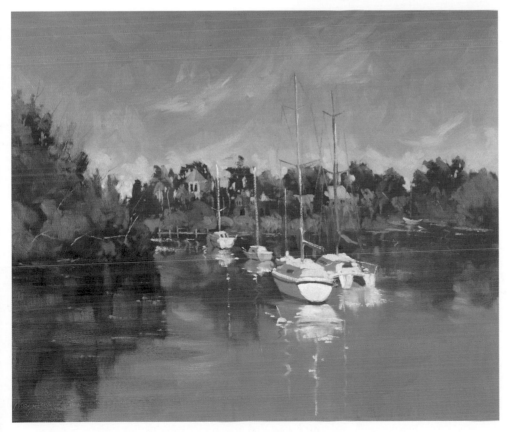

Putting It All Together

Work side by side with Morgan Samuel Price as she guides you through six complete step by-step demonstrations that tie together all the lessons in the book.

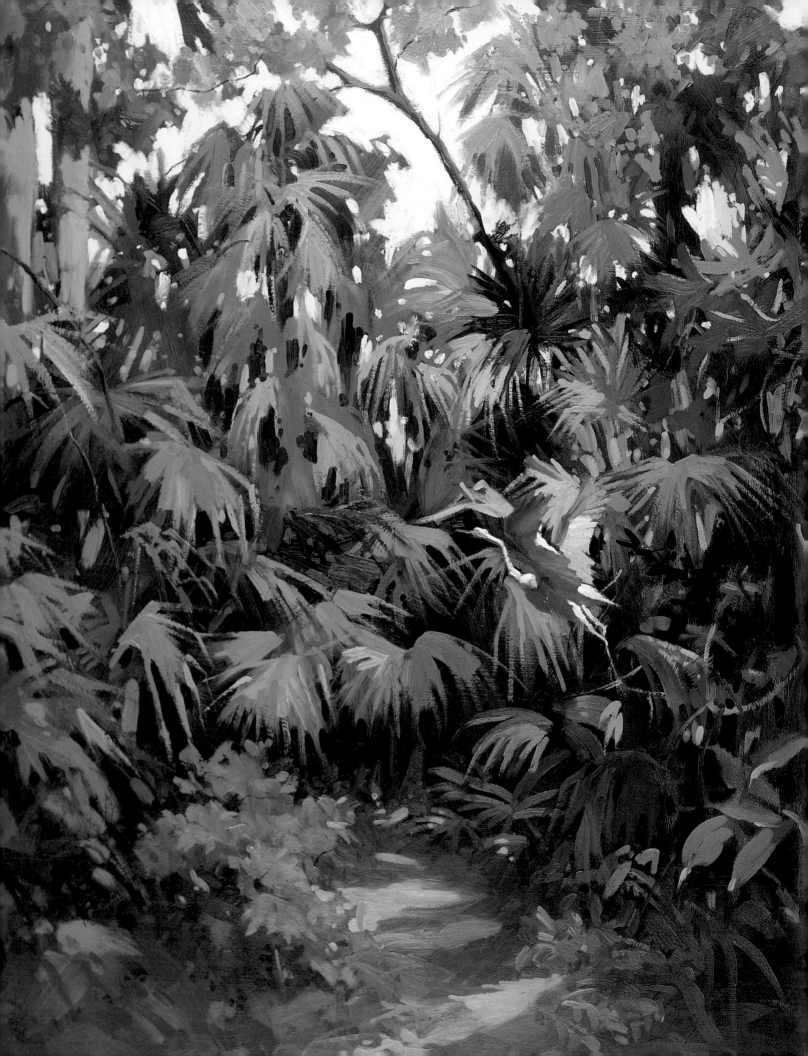

Some Thoughts on Creativity

What is the creative process? For me, it is the manner in which I measure the variables at hand and choose a path of presentation. The starting point of that process, naturally, is the philosophy which underlies my artistic choices and guides the path that I choose to state my point. It helps define why I paint, what I paint and how I make my choices.

Never confuse creativity with painting your mood—the mood of the artist should be immaterial. My personal mood has absolutely nothing to do with my creativity. On any given day, I might feel as if I were the most unhappy person on the face of the earth, but I still go about painting the most gorgeous landscapes I can.

Now, this does not mean that you need to suffer for your art. It simply means that as an artist, you do not want to be controlled by your mood. You must remain focused on your sensitivity to the natural world and to your personal experience in responding to that world.

To paint successfully, you must learn to "paint the moment." Paint the moment because you are there, able to judge the whole scene before you, and able to share the understanding and the feeling of that particular moment. In my work, I am driven to present a clear understanding of the condition to the viewer so that he can feel the subject. I also want to entertain the viewer in a manner that is pleasant, whether that pleasure is derived from the experience of the wind, the rain, the sunshine, or from some other natural element found in the work. These experiences may be common, everyday occurrences, but they evoke a range of feelings rooted in the enjoyment we all feel from being alive.

McKee Jungle Garden, 30″ × 40″ (76cm × 102cm)

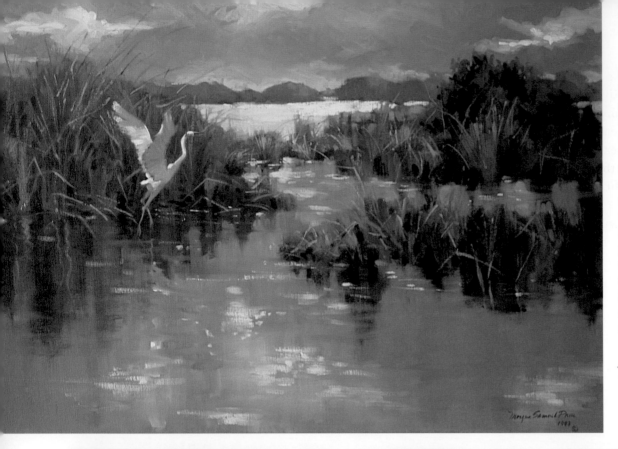

One of the biggest challenges a painter faces is to fully capture a moment in time. For example, it's not enough to paint a beautiful tree; rather, the artist must strive to paint the tree in the wind, or in the sunlight or in the heat of the day. The important thing is to communicate a particular moment to the viewer in a manner that is both appealing and satisfying.

Just Leaving, 30″×40″ (76cm×102cm)

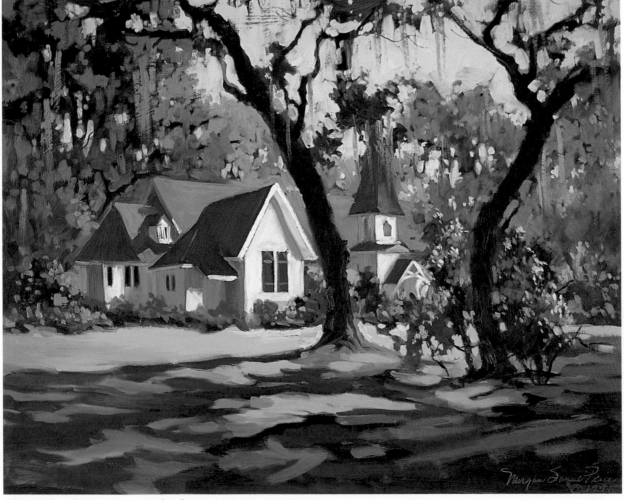

Christ Church, San Simeon Island, 24″×30″ (61cm×76cm)

Your success in painting the moment depends on holding the viewer's attention. Your aim must be to hold the viewer's attention so she will enjoy the discovery of all that is in your work, even those features that she may not at first have noticed.

In this book, you will learn how to paint the moment. You'll learn how to use value to build space and form, how to mix color with a basic palette, and how to design successful paintings. And you'll work through step-by-step demonstrations that tie all the lessons together. Look for my critical comments as you work through these lessons. They will provide tips and advice on what works and what doesn't, based on my thirty years of experience.

On a final note, always strive to paint in an uplifting environment—one that is kind to your spirit. Surround yourself in nature, and let your senses be flooded by beauty and serenity. Then, accept the challenge of capturing it in your work.

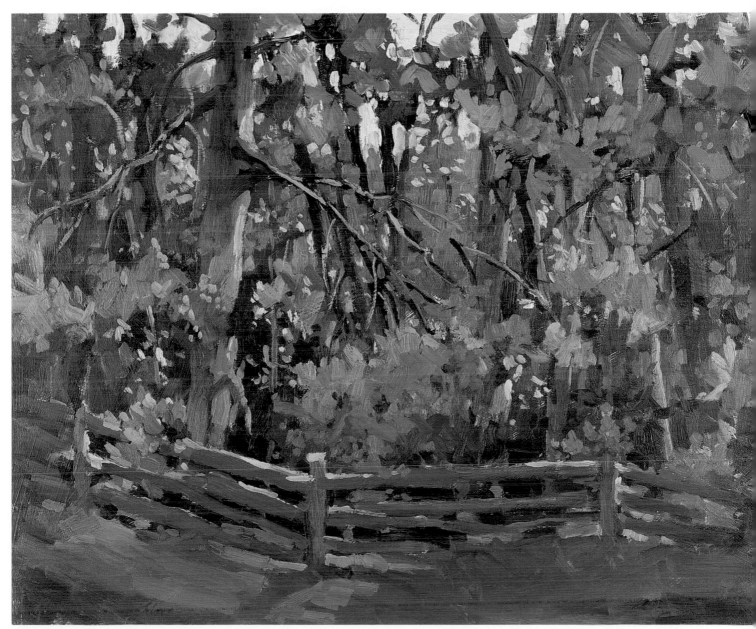

Autumn Fire, 24″ × 30″ (61cm × 76cm)

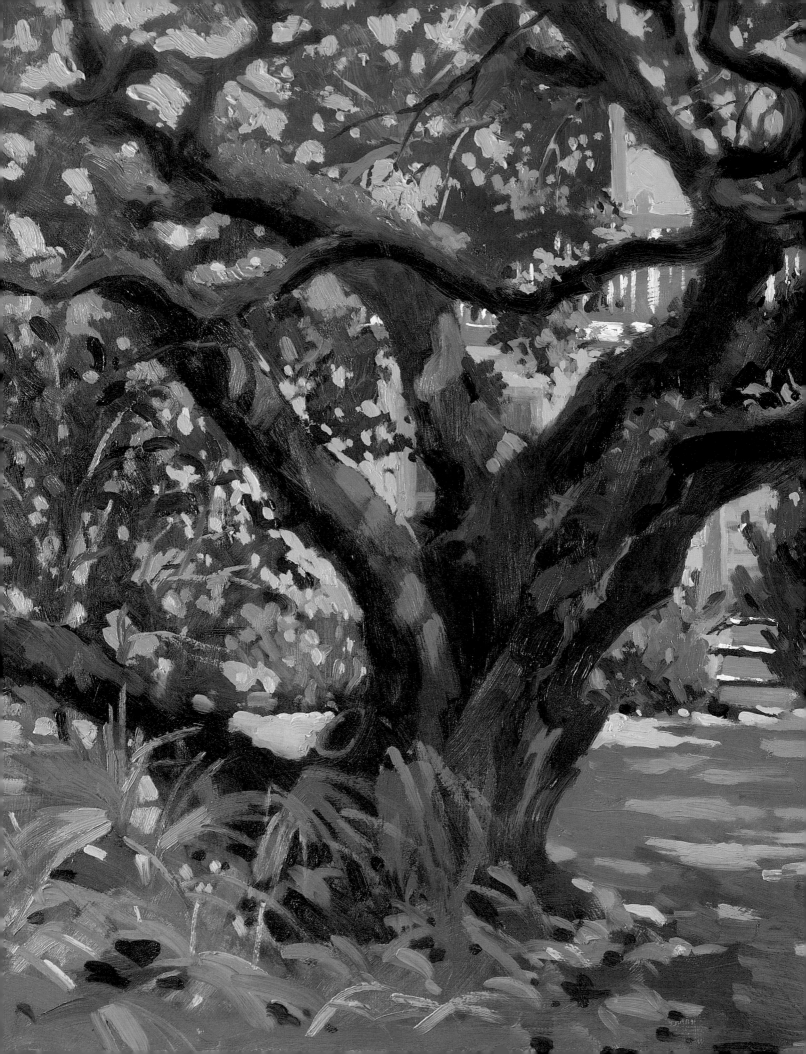

Getting Started

Sandfly East by Northeast, 24″ × 30″ (61cm × 76cm)

Choosing Your Equipment

Your choice of painting equipment is critical to the quality of your product, the result you expect to achieve. To paint well, serious artists invest in their equipment knowing the investment enhances improvement and success. My discussion here focuses only on the equipment I use rather than reviewing the full inventory of what's available in the marketplace. I'll tell you what I like and why.

BRUSHES

Top quality brushes are well worth the money you will spend for them and can be used for more than simply putting paint onto your surface. I even mix my colors with my brushes rather than with a palette knife, as I have found that using a palette knife interrupts the flow of my painting, unless, of course, I'm working on a palette-knife-only painting. By using my brushes that way, I gain more sensitivity to color and use a little less paint. I may wear the brushes down a bit faster, but I feel more than compensated by what I gain in the sensitivity of touch.

Look for brushes which have good, natural spring and well-defined flags. Spring is the brush's ability to bounce back to its original shape. High quality brushes will always have excellent spring. Flags are the subtle tips which form as the bristles separate when loaded with paint. Brushes with good flags will have excellent paint-holding capacity.

Brush Material

Bristles in top-of-the-line brushes come from the Chungking region of China. I use white hog's hair bristle, a natural fibre that comes from the back of a hog. This type of brush requires little pressure, has the capacity for actually holding more paint than other types and releases the paint easier. These are all important characteristics to me, as many of the effects I achieve are actually accomplished by changing brush pressure rather than by changing brushes.

It isn't always necessary to use top-of-the-line products. For example, sable brushes, though of slightly lower quality than white hog's hair bristle, are really quite good. I have great confidence in them and use them for portrait

and miniature work. I do not, however, recommend synthetic brushes, or brushes of a natural/synthetic combination for landscape work. I find the quality of brushwork unacceptable because they don't deliver the desired texture or appearance.

Brush Size

The size of your brush is significant because, logically, you want to match your brush size to the type of work at hand. If you are building a small figure or covering a small area, use a small brush. If building large figures or covering large areas, use a large brush to accomplish this easily. So, in choosing your brush, take into account how much paint you intend to lay out and how fluid you intend your painting motions to be.

The Three Types of Brushes

Three kinds of hog's hair brushes include the bright, flat and filbert as illustrated. A bright brush has shorter bristles than a flat brush, and for that reason I don't generally use it because it's too rigid and far less flexible. By contrast, the filbert brush has longer bristles than the flat. It tends to be quite floppy, with too much give, and because of that, it limits my control more than I am willing to allow.

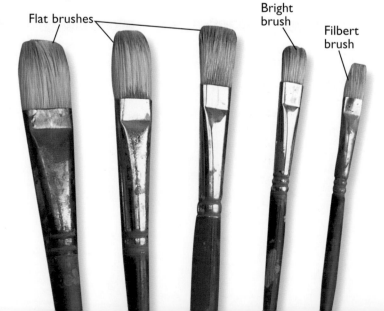

Flat brushes

Bright brush

Filbert brush

Brush Corners

I prefer brushes with very crisp corners. I can make a variety of strokes with the corners to get a broad range of particular effects.

Thanks to those corners, my flat brushes are very effective, and I very rarely feel the need to use a rounded brush. For example, if I

want a linear effect, I use a crisp corner rather than the tip of a round brush.

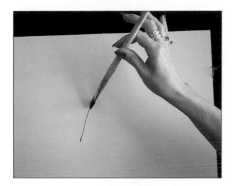 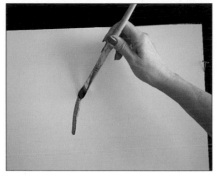 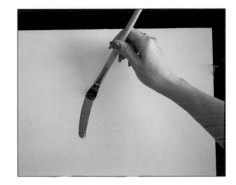

Using Your Brush Corners

A variety of effects can be had through effective use of your brush corners. The first of these three illustrations shows how to achieve a thin line by using the brush on edge. The second illustration shows how to paint a medium line by using the brush edge held at a three quarter angle. The final illustration shows how to paint a full, thick line by holding the brush edge flat.

Brush Care and Cleaning

Proper care and cleaning of your brushes is a must. Either use a professional brush cleaner or ensure that you wash your brushes to the ferrule with warm soapy water after each use. Start by

lightly twirling your brush on the top of a natural, pure soap bar. Twirl the brush into the palm of your hand using a gentle pushing motion to get the soap into the ferrule. When you no longer see

color coming out, the brush is clean and you can straighten out the fiber and flatten/reshape it by "scissoring" the brush between two fingers.

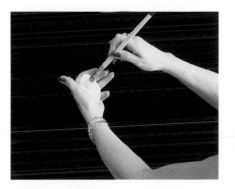 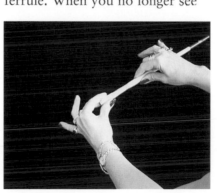

How to Clean Your Brush

This illustration sequence shows the proper way to clean your brush. Swirl the bristles around on a bar of natural soap in a circular motion. Once no more paint comes out, reshape the brush with your fingers. Finally, flatten the bristles by scissoring the brush between two fingers.

PAINTING SURFACES

My choices of painting support include: untempered Masonite, Belgian linen and four-ply museum board mounted on foam core. Of these surfaces, Masonite is clearly the winner. It is a long-lasting, sturdy support requiring little upkeep and, in the long run, less restoration. You also have the choice with Masonite of using the smooth or rough side. The rough side does wear down your brushes, but the effect is worth it for a change of pace.

In contrast, the less sturdy Belgian linen moves easily in handling and, because paint becomes very brittle over time, the oil paint film may crack because of this movement. To increase the longevity of the oil paint film, stretch the linen over Masonite for a good support that offers minimum risk of tears or punctures. Of all fabric supports, I prefer linen because of its quality and change in texture, but bear in mind that untreated linen offers

APPLY LINEN OVER STRETCHERS

An alternative to mounting linen on Masonite is to stretch it using stretchers. Prepare the linen surface with an application of rabbit-skin glue. Let it dry and lightly sand it. Then apply one coat of gesso, let dry and sand lightly again. Repeat this step. This will give you a slightly different kind of linen surface to work on. Though linen requires much more caution with how it is handled, when properly prepared, it offers a unique look and good longevity.

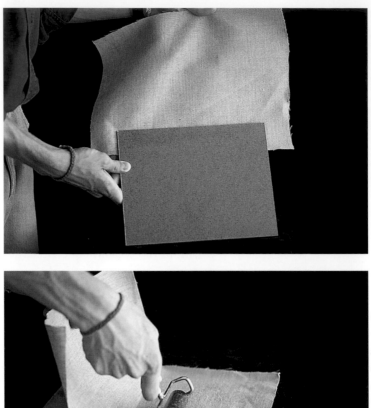

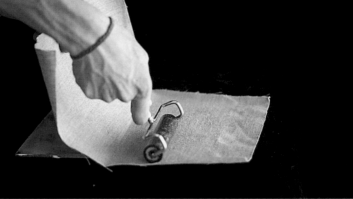

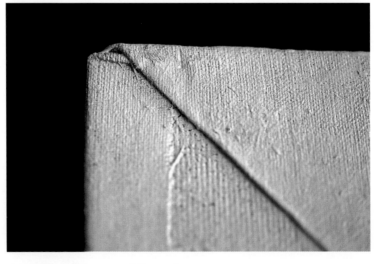

Applying Linen to Masonite

Use a water-based glue to adhere linen to Masonite. Work with a brayer to push it onto the Masonite; do this as if you were covering the Masonite with wallpaper. Allow enough linen to wrap it fully over the edges of the Masonite. Be sure to roll out all air bubbles. Cover the surface with an evenly distributed weight and allow to dry. Fold the linen under the edges of the Masonite, glue and let dry. Then apply the gesso: two coats on the front and one on the back. We have now created the proper barrier between the linen and the oil paint you will apply later.

no longevity because the fibre will rot without proper preparation.

Another option is 100% acid-free four-ply museum board. To obtain a gray surface with plenty of texture, apply two coats of gesso. When it is mounted on a piece of foamcore board, museum board offers many of the same qualities as Masonite, but Masonite is my first choice.

Coating Untempered Masonite

Whenever you use Masonite as a support, apply acrylic gesso to it to provide a barrier between the support and the oil paint. This prevents the oil in the Masonite from seeping through later and forming brown spots on the surface of your painting. Before using this surface, tint the gesso with universal tint or colorant at a value in the upper range of your value scale (on a value scale of 1 to 10, try 3). Using a two-inch brush, apply two coats, undiluted, to the surface and put one coat on the edges and back. Brush on the second coat after the first has dried. Do not sand the surface if you want the brushwork of the gesso to show on the panel. You will notice a light texture after the gesso has dried which is preferred over a slick painting surface.

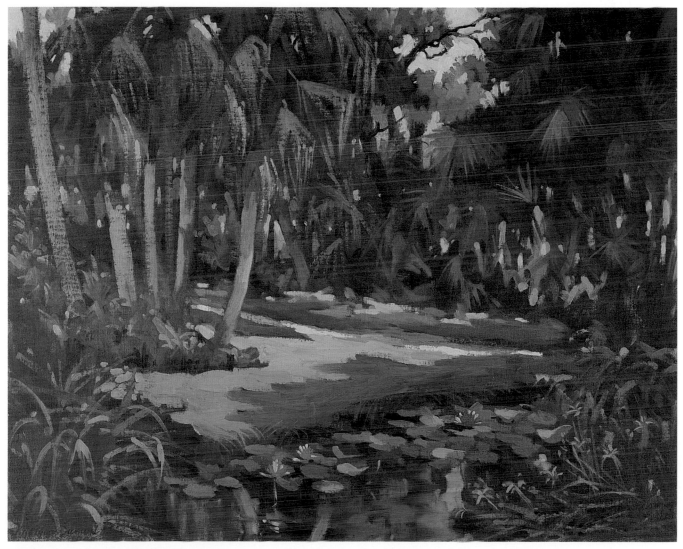

Gleason's Pond, 24″ × 30″ (61cm × 76cm)

MY PALETTE

My limited palette usually consists of six colors plus Titanium White, placed in the corner. These six colors are Cadmium Yellow Pale, Cadmium Red, Crimson Lake (or Alizarin Crimson), Yellow Ochre, Cerulean Blue and Ultramarine Blue Deep. On occasion, I add Burnt Sienna, Viridian, Phthalo Green, Prussian Blue or Cobalt Blue to my palette, depending on my color choices.

Your color selections are vital but the setup of your palette is also key. A consistent setup will help you maintain order. In this context, the consistency of your palette setup saves you time and energy and keeps you organized. Try to get into the habit of setting up your palette the same way each time. These are long-term advantages for any painter.

Research Your Paints

When you choose what pigments to work with, read the manufacturers' labels and other specifications to know exactly what you are buying. For example, you'll want all of your paints to dry at about the same rate, as it will help avoid having the paint crack down the road. Look for a high rating of permanence and lightfastness in the colors you choose so that you ensure that what you see is what you get for years to come. And though humidity, temperature and the amount of light displayed on your painting can always affect color permanence, careful pigment choices can minimize these damaging effects. Be careful in your selection of materials, and bear in mind that if you do not make sound decisions in regard to your pigments, what you paint today may not be around in the future.

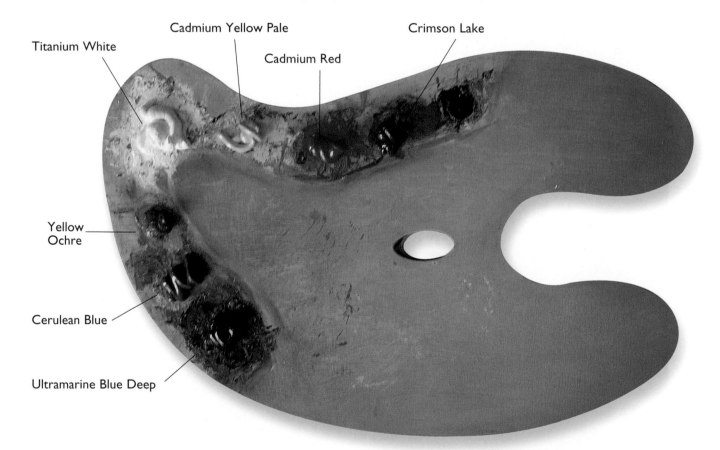

Titanium White

Cadmium Yellow Pale

Cadmium Red

Crimson Lake

Yellow Ochre

Cerulean Blue

Ultramarine Blue Deep

My Palette

This photo of my palette shows both the arrangement of color and how to spread your colors out so you can see the changes more easily as you mix colors together.

MEDIUM

When your paint is not flowing or releasing from the brush well, and not covering as much area as you desire, the addition of medium makes it easier to extend the paint so that it flows nicely. Medium is the vehicle which allows you to extend your paint, and gives you a fast setup time. Because it allows your paint to dry quicker, it is important that your medium have a low yellowing factor. Experimentation and experience will help you learn to find the correct amount of medium to serve your purpose.

Medium is frequently used for creating a transparent quality to the appearance of your paint. But be careful that you do not use too much medium because your paint will become too fluid and difficult to control. You'll find that it's like working with soup if you try to lay one color over another. Be careful with your proportions.

The general rule for paint application is "fat over lean." "Fat" is paint with medium; "lean" is paint without medium. The physical reason for not applying lean over fat is that, after a time, paint with medium dries faster. The difference in the drying times between lean and fat paint causes cracking if the paint is applied incorrectly. Once you've started using fat paint, you must continue with it. Also, if you need to rework an area after the paint has had time to dry, you must use medium so that the fresh paint will bind to the surface.

MAKE YOUR OWN MEDIUM

Put this recipe for a high-quality medium in a safe place. In a separate container, mix together 2½ oz. gum spirits of turpentine, 2¹⁄₂ oz. damar varnish (heavy solution) and 1 tablespoon stand oil. (Stand oil is linseed oil that has been heated and is thinner than regular linseed oil. In this mixture it retards the varnish so it does not set up as fast.) Then pour off and use just what you need for each work session.

Transparent

Transparent vs. Opaque Paint

In these two examples, notice how the left color swatch has a transparent quality to it, while the right color swatch is much more opaque.

Opaque

Using Your Equipment

Learning to paint is similar to learning a musical instrument or acquiring new sport skills. Your ability to learn depends to an important degree on how much you practice the basics of your chosen activity. Mastering the use of your brush is just one area of painting where learning through practice is a necessary process. Brushwork plays such an integral role in your ultimate success. Remember, every stroke you make should mean something. Each stroke must accomplish a particular purpose.

HOW TO HOLD A BRUSH

Let's start with a few of the essentials. First, hold your brush as if you are "painting a wall." Loosen up. Consciously relax your brush hand to the point where someone could slide the brush out of your hand with little or no resistance. If you stay this relaxed and hold your brush at a comfortable angle, you will be able to effect a complete range of angles to the painting surface and gain the necessary ease of unhindered hand and brush movement.

Don't try to hold your brush as a pencil. You'll tend to increase pressure on the shaft of the brush and you'll choke up on the metal band (called the ferrule) of the brush. You will not have the same ease or ability to control your pressure, while the relatively tight hand required for a pencil grip becomes fatiguing. As you increase your painting time, you will use a combination of grips, but I recommend using the pencil grip the least, and only when it consciously makes sense to do so.

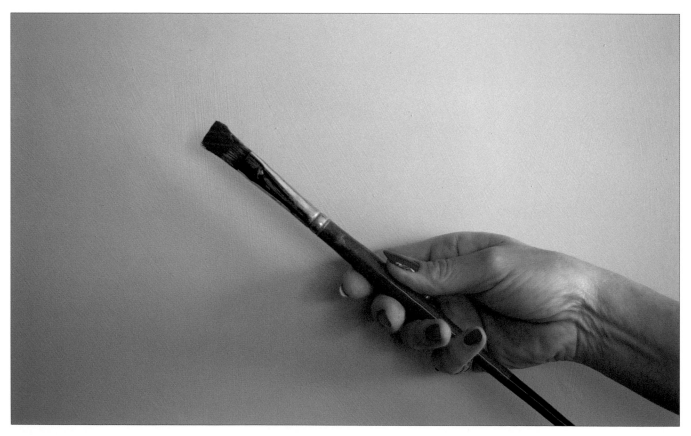

How to Hold Your Brush

Hold your brush loosely, in a relaxed manner, as if you were painting a wall.

EXERCISES

Now, a few brush exercises. Any exercise you do should be deliberate and purposeful. You are trying to achieve and control a sense of action and result/effect. With practice, you will gain dexterity and a growing ability to render an expressive line and gain the understanding of how to select just the right amount of paint to produce a range of desired effects. However, it does take time to get acquainted with your brush and gain confidence in your stroke.

Exercise 1

Try crosshatching to fill a large area.

Exercise 2

Practice blocking an area while ensuring that your paint is applied in a manner similar to a flat tone.

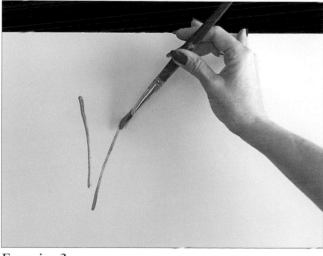

Exercise 3

Use the corners of your brush to make very thin strokes both horizontal and vertical.

Edges

The illusion you are striving to create for a given subject comes from its edges. The edges tell the story and say more about the illusion than the average painter is usually aware of. So pay particular attention to the edges. They are ultimately one of your strongest tools in depicting the type of illusion you are striving to create.

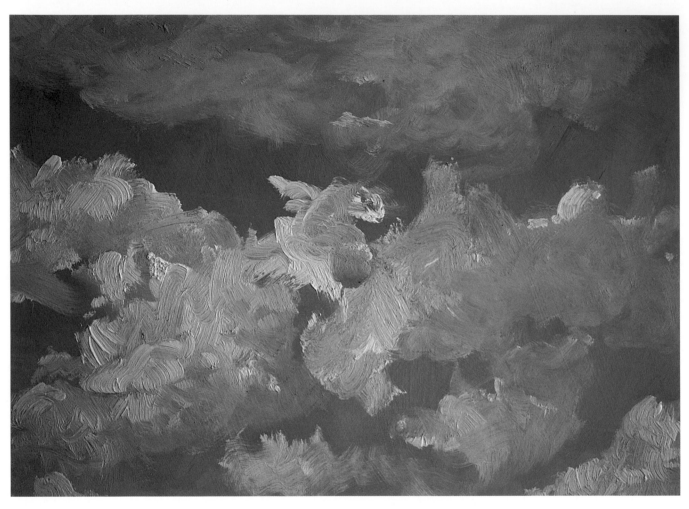

Exercise 4

Try painting clouds with the correct textures by using the full width of the outside edge of your brush. Apply paint as if you were actually running your hand over subjects like trees or clouds. A brushstroke following the plane will often enhance the construction of the illusion you are trying to create. More than anything else, mastery of this technique will help you tell the viewer what is represented in your painting.

Exercise 5

Practice manipulating your brush to create the edges and brushstrokes on the foliage shown here. It's a great way to learn what your brush is capable of doing. A good painter has confidence in each stroke because he or she understands what the possibilities are and works for expressiveness.

When well done, your brushwork should convey a line of direction, create a shape within a shape, create an edge, create a static feeling or create feelings of softness. If you get the idea that a brush stroke is not just a brush stroke, then you are beginning to understand that each stroke must have purpose.

Think about it. If you have confidence in your brush stroke, you will believe in your choice. You will put down a stroke with conviction and leave it, rather than go back for rework. Avoid changing a stroke and fretting over it until you've killed its power. Made once, a good stroke has tremendous power and conveys many issues. The more you discover about handling your brush, the more expressive you can be with your brush stroke. Have fun expanding your repertoire!

Layer Your Paint

If you are uncertain about how to lay one color on top of another, here's a way to help develop your dexterity with the brush. Paint a surface solid black, but don't let it dry. Now, paint a crisp white over the top of it. Try to avoid any shades of gray. When you have accomplished this perfectly, you will have learned how to apply one layer of paint over another. One hint: As you paint the dark area, the paint should be thin. The white or lighter area can be a thicker paint.

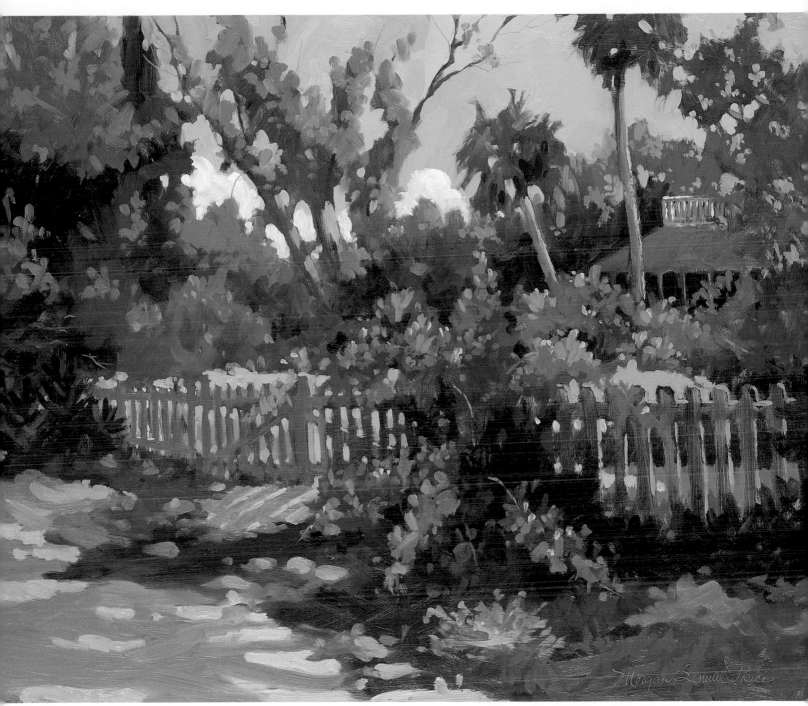

Bougainvillea, 24″ × 30″ (61cm × 76cm)

This painting was painted in a direct oil technique, meaning there was no underpainting and the oil paint was applied directly to the surface of the support, in this case a wood panel. This painting was done in an "alla prima" fashion (all paint applied in one session). Though I began this work without using any medium, after the initial block-in, I changed and started to use it, continuing with it through the remainder of the painting.

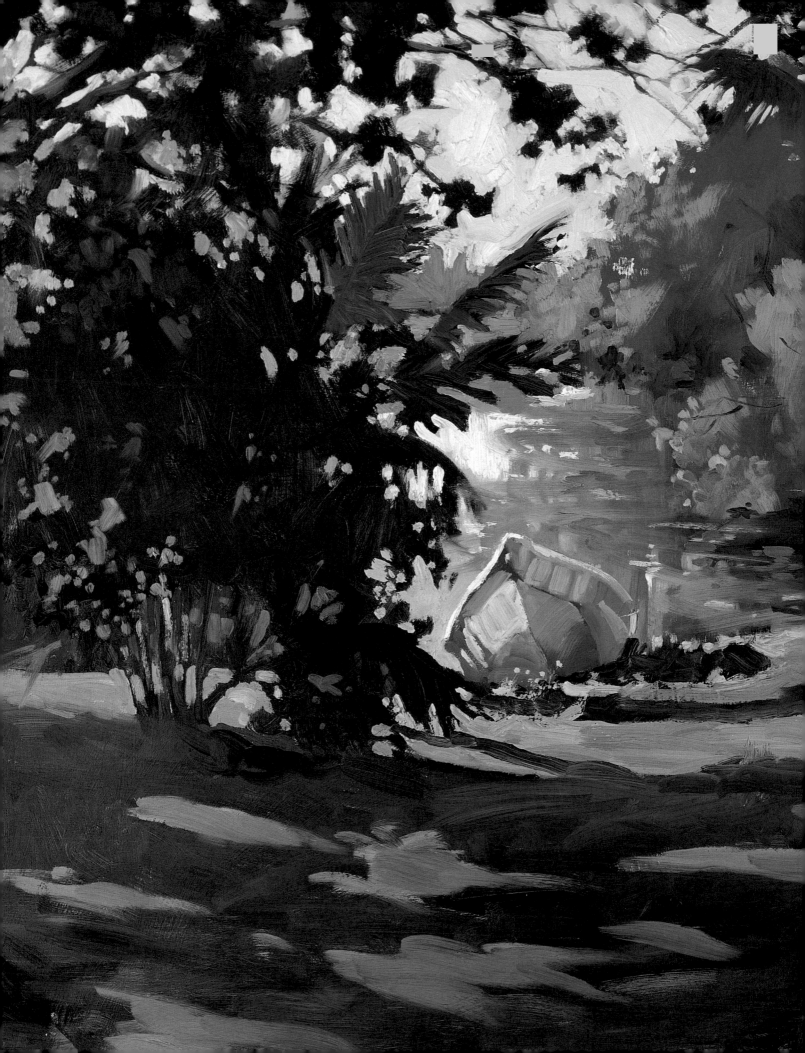

Use Value to Build Space and Form

Orchid Island Row Boat, 24″ × 30″ (61cm × 76cm)

What is Value?

Value is the relative darkness or lightness of the hues an artist selects to represent an object. It is the strongest tool in the painter's tool kit for showing form and space. You attach value to absolutely everything in your painting. The array and contrast of values you choose enables you to build form and space. By working with and mastering value, you learn to create the illusion of the third dimension and learn to create a particular atmospheric condition.

VALUE SCALE

A black and white value scale is the starting point for studying, understanding, practicing and using value properly in your work.

In my career, I have painted literally hundreds of value scales, and I am sure I will paint hundreds more. Judging value is a bit like opening another door of perception, because an understanding of value presents a new way of seeing!

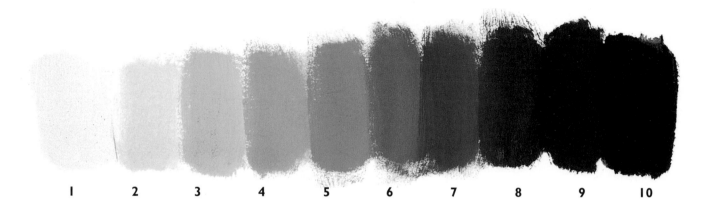

1　　2　　3　　4　　5　　6　　7　　8　　9　　10

Make a Ten-Step Value Scale

I recommend building your fundamental value scale from 1 to 10, with 1 being pure white and 10 being pure black. All other numbers on your scale will be a range of discrete shades of gray. To be effective, each value must distinctly contrast with those adjacent to it. Constructing your value scale requires plenty of practice and considerable effort. Don't look for short cuts! You must get a handle on your value scale before you can truly progress in your work. If you intend your work to effectively show three dimensions, you must master value. This requires tuned, sensitive eyes and a heightened awareness of value as a critical tool.

TRAIN YOUR EYE TO SEE VALUE

During your work with value scales, you are going through a very important process of training your eyes to identify what you see and attach a value to it. This process begins in black and white. Later, you mentally refer to your black and white values during the selection of any other color you choose to make in a painting. Whether your black and white scale is just carefully stored in your memory, or whether the scale is physically before you, transfer what you have learned about value in black and white and relate it to color. All color has value.

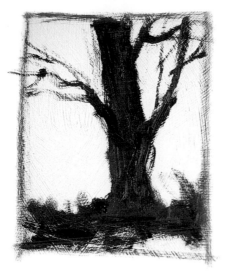

A One-Value Study

Here is a sketch of a tree using only one value.

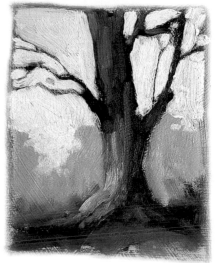

A Multi-Value Study

Here is the same tree sketch, but this time I've used multiple values to indicate the direction of light.

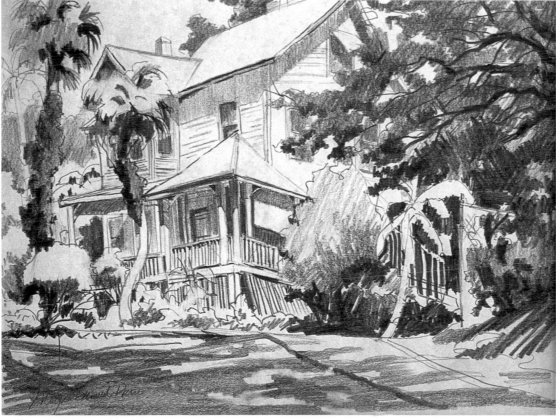

Hilltop, Graphite, 8½″ × 12″ (22cm × 30cm)

Keep Your Values Simple

In this sketch, I used values that correspond to the ten-value scale on the previous page (with 1 being the lightest—white—and 10 being the darkest—black). Most of my value sketches use a simplified scale of only four values: white, 1; a value of about 3 (half light); a value of 7 (half dark); and black, 10. By using this simplified scale, you keep your drawings quick and easy to render, and keep them simple to "read" and use in the development of future paintings.

VALUE CONSISTENCY

Value consistency is the key which gives you a disciplined, reasonably standardized framework that will enable you to show form and space throughout your work—painting after painting after painting. The black and white value scale is the foundation to this framework. By relating color to your black and white scale, you have a way of judging what the value of that color is.

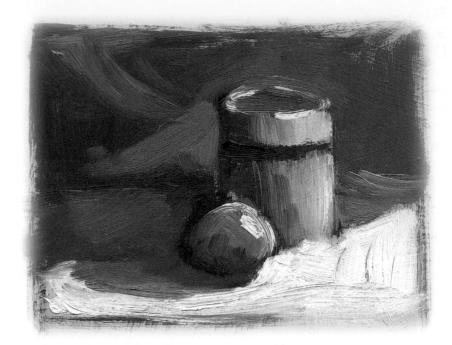

CREATE FORM AND SPACE

Just as you can create form and space in black and white, you will be able to create them in color. Approach value and color in the same way to build a painting; don't separate them. First put in lower middle values; then add the lighter values. Build toward the light. I build from dark to light because it's far easier to control than going from light to dark (the other is not impossible, but it is a more difficult choice and a bit more time-consuming).

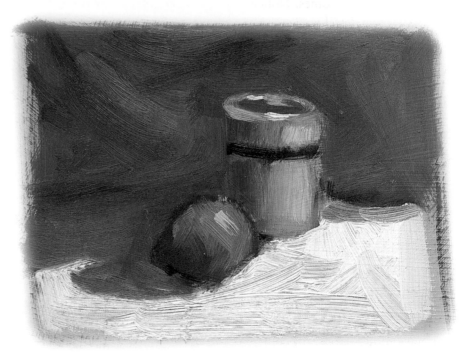

Paint the Light

Your ultimate mission is to "paint the light." To fulfill this mission, paint the effects of light on a plane. Each color has a value, and each of those values has a relationship to each other in building the plane you are depicting. The value of each hue is the most important feature in order for your color to appear to be in the correct value and contrast and on the right plane.

Compare these two illustrations. Notice how the colors in the one on the bottom correspond to the value study on the top. Form and light direction are clearly defined thanks to a disciplined use of value.

SEE VALUE BY SQUINTING

Get in the habit of squinting your eyes to "see" the values in your subject. Squinting helps you stay focused on values only and simplifies the values you are able to detect. What you see is in focus with distinct values and sharp differences. Take a look out the window and try this now. Tighten your eyelids into a squint and check what you see. Minimize what you see to just the shapes—medium and dark shapes against the lighter values and the light of sky. Determine where the light is, how much there is and the direction from which it comes. Notice how much less detail you see with a squint and, consequently, that you see the main value changes rather than a myriad of detail.

While squinting, start comparing the lights and darks of your subject to the values of white, gray and black you have already constructed in your value scale. As you make your comparisons and mix your paint accordingly, the color you compose must match exactly the value you see in the subject itself. This is what value is all about. Don't rush the decision to determine what values you have found. Constant comparison is always necessary to correctly judge the values.

Squint to Judge Value

When you squint your eyes, the colors in each of the above examples should mesh. When that happens, you know you have the correct value. Try it now, and watch the colors mesh together.

TRAIN YOUR EYES

All too soon we all face the issue of determining whether or not we have selected the right value. The answer lies in carefully matching what you see while squinting with its corresponding value on your value scale. When the two "mesh" and you cannot tell one from another, you've got it. The value of your color is now attached to the value scale. This is how you train your eyes to see value.

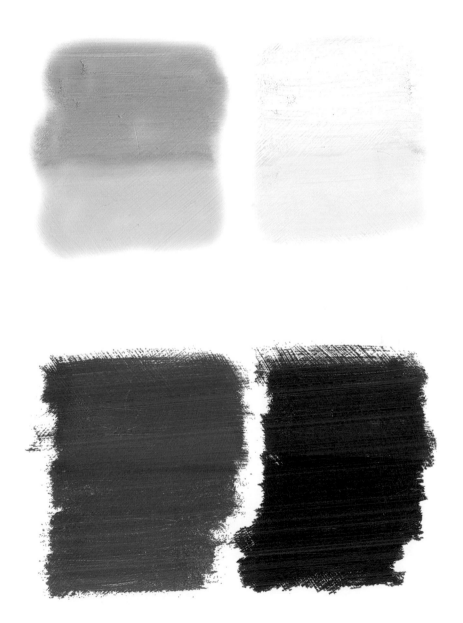

Simplify Values

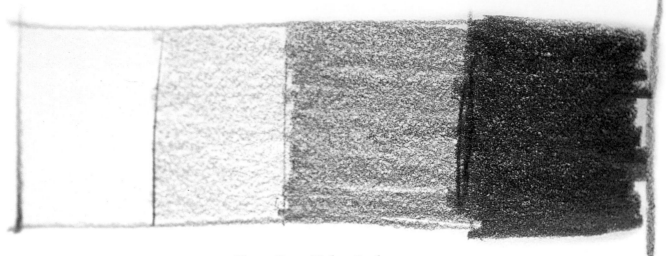

When you make your value choices, simplify how many values you select. Simplicity is strength. If you make too many value changes, even in just one area of your work, you run the risk of breaking up your work into too many little pieces. Reduce the number of values, however, and you begin to achieve a simple, striking effect.

Some people have a natural aptitude for setting values. This is a great asset to your painting if you are gifted with this ability. But no matter how gifted you are, the skill for selecting values is one that requires regular practice and use. Remember, you *can* develop this ability. This skill, like those involved with playing a musical instrument or singing or dancing, must be developed and fine-tuned to remain strong and accurate. You may have to rebuild the skill if you have fallen out of practice.

Use a Four-Value Scale

Four values is a good rule of thumb: a light, a half light, a half dark and a dark.

MAKE A SPYGLASS

Here's a practical suggestion for developing your sense of value. Make a "spyglass" by forming a tiny circle with your thumb and finger or with your whole hand, whichever is more comfortable. Keep the opening of your spyglass quite small, perhaps one-quarter inch in diameter. With your arm extended, look through your spyglass and concentrate on what you see through your "lens," looking for patterns of light and dark. This helps to isolate and compare areas within any frame you select. By isolating and comparing different areas, you are better able to judge the values of the patterns you find in one area with those in another. This comparison is vital to working out the value of what you see.

Show Form and Space With Value

Let's move from an understanding of value to the process of using value in your work. Black and white studies or sketches are a good place to start, and whether or not you use pencil, charcoal or paint, the method is the same. Our purpose is to become effective in using value, and contrasts in value, as a means of showing form and space.

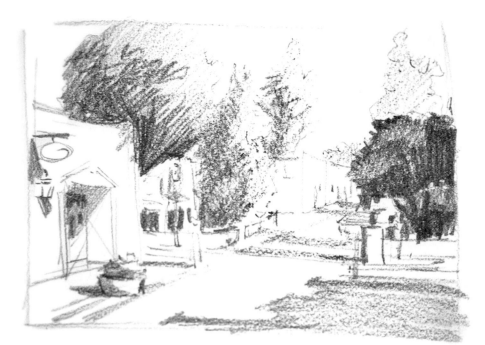

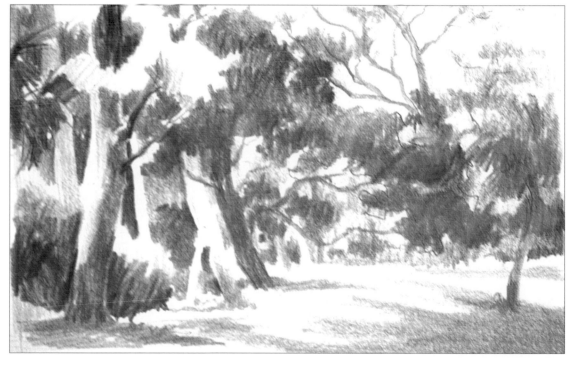

Make Simple Value Sketches

Keep your sketches simple, as shown in these two examples, since we are not looking for much detail. Rather, we are trying to depict the direction of light. Begin by drawing just a few major masses in your frame. Keep these large and simple. Even now, we are trying to attract the eye of a viewer by working on interesting shapes, with edges that lead and entertain the eye.

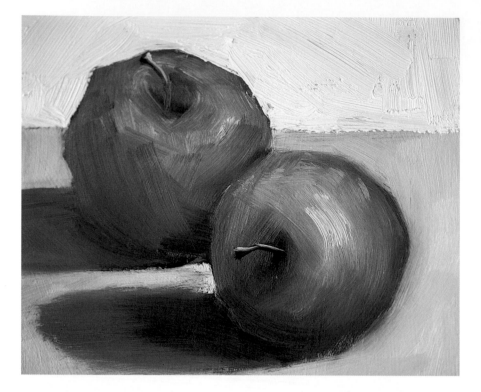

Block in Simple Values

Once you have the major masses in place, you need to define and block in their values. Remember to use the squinting and spyglass exercises. They will help you to find and draw out your value without getting lost in the detail of your subject. Think in terms of using three to four values as a way of approaching what you need to show during this blocking-in phase.

As shown in these two examples, start with your lower (darker) middle values, probably in the number five to number seven range on your value scale. (This is not, however, a paint-by-number proposition!) Continue this process of value selection, working next toward the light, the upper midrange of values. Finally, work in your lightest values; add dark accents; use white for the areas of strongest light.

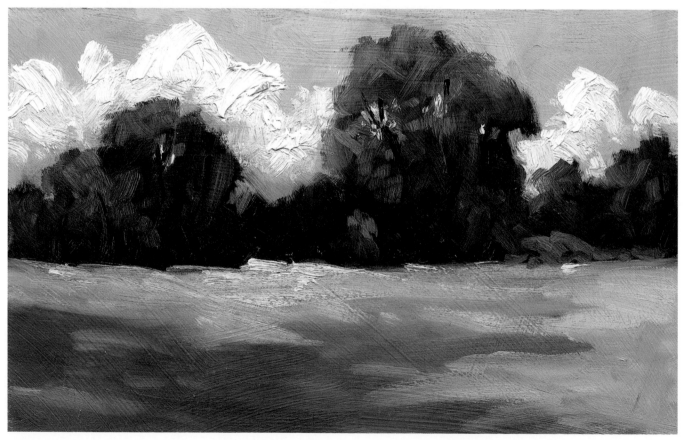

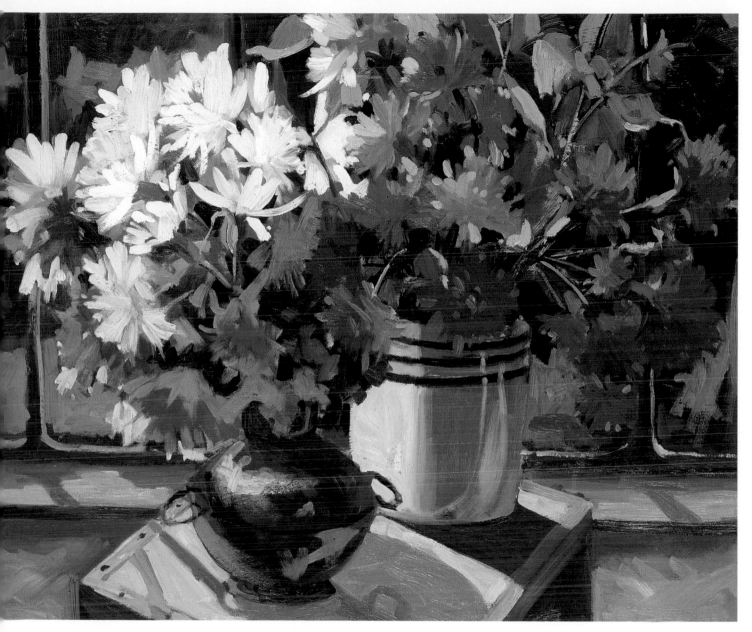

The Final Outcome

When all is done, and done well, through effective use of simple values, you'll end up with a painting that conveys reality and depth without appearing busy or cluttered.

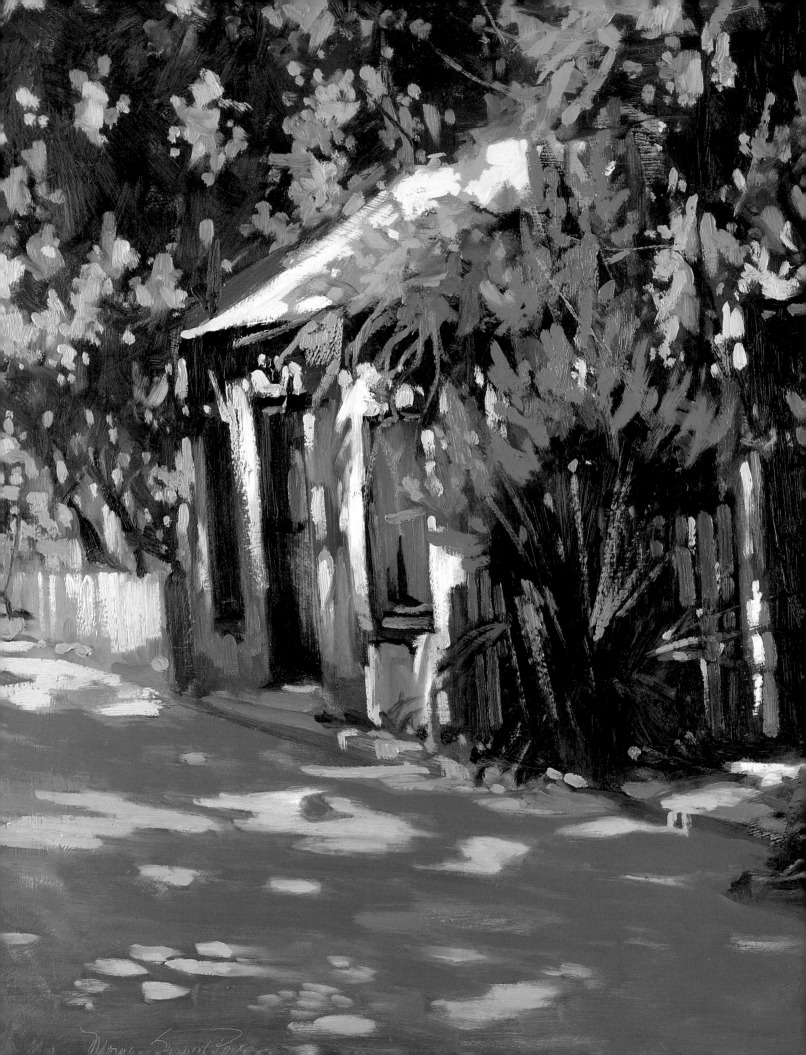

The Economy of Color

Working with color is fun, dramatic, emotional, visceral, personal. Good use of color is a major building block in capturing the eye and imagination of the viewer. Well-used, color is a major feature which enables your viewer to experience that "I am there" feeling about your art. It lets the viewer clearly see the essence of your subject and how you, the artist, are responding to what you see and feel about your subject.

As a very young artist, I started with a much larger array of color on my palette. But as I continued painting, I discovered I just did not use all the colors I was laying out. I realized that if I was not using certain colors, why buy them? I saw the sheer economy of other artists and thought to myself, if they could work with just a handful of colors, I should try it too. What a discovery!

I was hooked on a limited palette and never regretted that choice, because I soon realized the endless array of colors that could be achieved. My success in mixing color on the palette depended on a thorough understanding of color theory and paying careful attention to those principles which are the groundwork for comprehending the use of value, intensity and temperature of color.

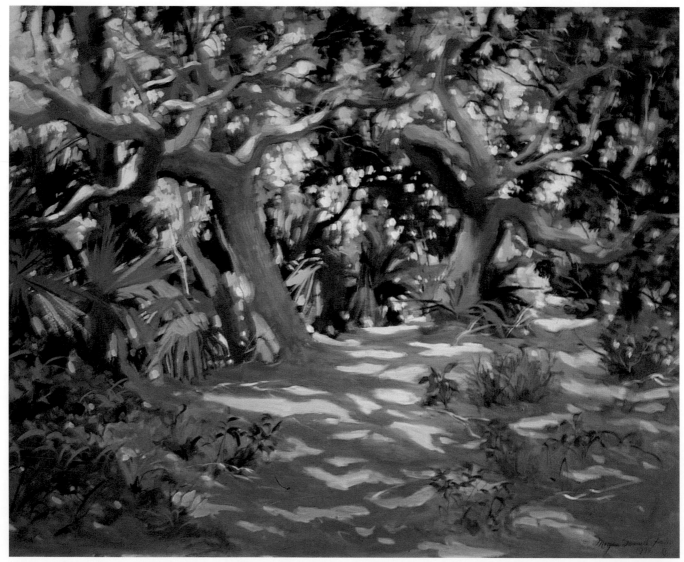

Interior of Canaveral, 36″ × 48″ (91cm × 122cm)

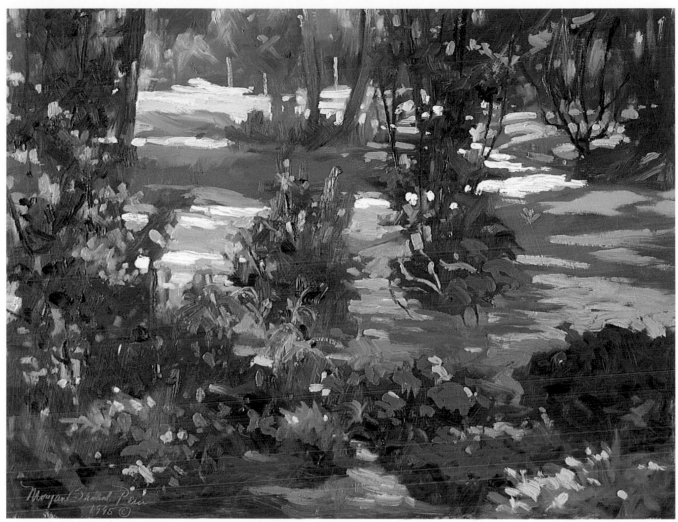

My color preferences are for the comfortable, soothing, palatable hues found in nature. I'm able to mix the drama and excitement I require from the colors of nature, without any garishness. My palette is limited, but as you can see in the paintings on these two pages, I can achieve almost any color required through careful mixing. I've never noticed that I'm at any great loss by not starting with a large array of colors.

Before the Planting, 16" × 20" (41cm × 51cm)

Experimenting With Color

Once you understand terms such as primary, secondary and tertiary colors, I believe you can mix almost any color you might need, rather than buy and use every hue straight from the tube. But unless you experiment with the colors on your palette, you'll be denying yourself the opportunity to understand, make, and use the full range of colors available to you. Color can be truly understood only through your personal experience with it. Give yourself the time to thoroughly investigate it. You must really invest in the process of discovering color, because there are so many colors you can create.

PRIMARY AND SECONDARY COLORS

The primary colors are red, yellow and blue. These colors have complements which are green, violet and orange. Complements are also known as secondary colors; they are made from the combination of primary colors. For example, when you want the complement of red, combine the other two primary colors (in this case, yellow and blue) and you make green. For yellow's complement, combine red and blue to make violet. For blue's complement, combine red and yellow to make orange.

Complementary (secondary) colors can greatly enhance your work with color. You can use them to modify or enhance a color. If a color appears garish, you can tone it down by adding the correct complement. You can take it back a step to make it more appealing to the eye. Too often, students are told that complementary color just serves the purpose of neutralizing another color. This approach underestimates what the use of complementary colors can achieve.

Primary colors

Red Yellow Blue

Green Violet Orange

Secondary colors

Primary and Secondary Colors

The three primary colors are shown in the top row, and their corresponding complements (secondary colors) are shown immediately beneath them.

SEE AND FEEL YOUR COLORS

By starting with a limited palette, you will begin to teach yourself how to use color effectively compared to just loading color on your palette straight out of the tube. The process of discovery is hindered rather than helped if your approach is to mix color according to recipe. Color recipes fail to tell you what a color should look like in your work and cannot tell you the exact order of mixing to achieve a certain color. You, as an artist, must see and feel the color before you try to present it in your work.

TERTIARY COLORS

Tertiary colors are intermediate colors and are combinations of a primary color and a secondary color: yellow green; yellow orange; red orange; blue green; blue violet; red violet. To correctly name them, state the primary color's name first. A tertiary color's complement is always another tertiary color—the one opposite it on the color wheel.

Tertiary Colors

Here are the tertiary colors, with each corresponding complement shown next to it.

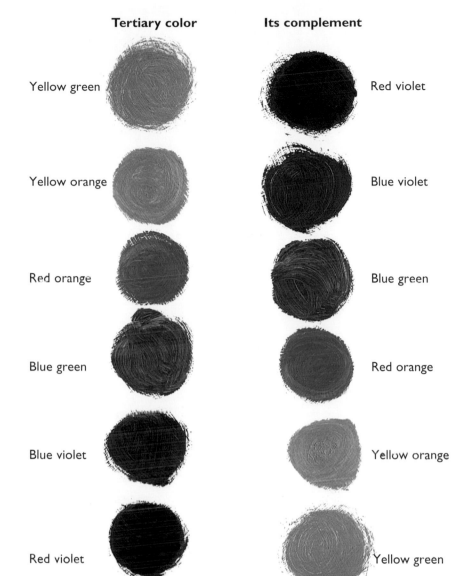

Tertiary color **Its complement**

Tertiary color	Its complement
Yellow green	Red violet
Yellow orange	Blue violet
Red orange	Blue green
Blue green	Red orange
Blue violet	Yellow orange
Red violet	Yellow green

The Color Wheel

Here is a typical color wheel. Notice the primary, secondary and tertiary colors and their relationships to each other. See how the complementary color is directly across from its primary color.

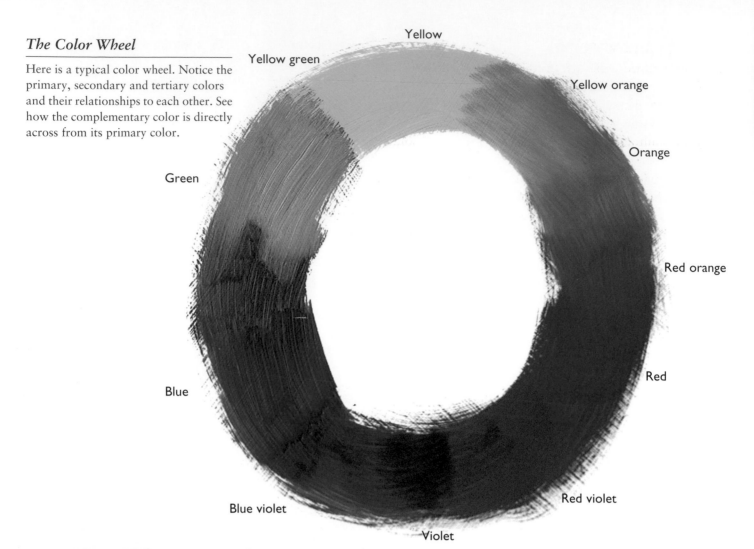

Yellow

Yellow green

Yellow orange

Orange

Green

Red orange

Blue

Red

Blue violet

Red violet

Violet

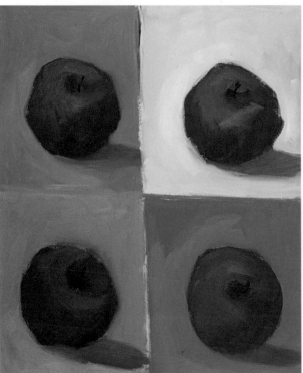

SEE COMPLEMENTS WITHOUT A COLOR WHEEL

Did you know that even without a color wheel, you can always visually see a primary color's complement? If you stare long enough at a dot centered on a piece of primary-colored paper and then close your eyes, you will see that particular color's complement. Try this exercise to see for yourself. Take a piece of red paper and put a dot in the center. Stare at the dot for a bit, and then close your eyes. The very first color that you will see with your eyes closed should be its complement, in this case green.

Adjacent Color Alters Your Perception

All color is seen in relationship to other color. Paintings are a combination of modified or neutralized color with small areas of intense color. The four apples that you see here are all painted the same value, but by changing only the background color, the perception of the color of the apple changes significantly. Note with the warmer background, the apple appears much cooler and darker. The two apples placed with cooler backgrounds appear much lighter.

COLOR LOGIC

A disciplined approach to the effective use of color will help you make good choices and enable you to progress in the quality of your painting. To start, you must have a clear-cut goal for using color to act as a guide for your color choices. Your choice of color, therefore, must have an established purpose. Your established purpose will then guide choices of value first, then color intensity, then color temperature.

As you work with color, ask yourself some specific questions: What is my goal with the use of a particular color? What exactly am I trying to make this color do? Where does it fit on the picture plane? What plane am I trying to depict? Am I trying to make the subject recede on the picture plane? Am I trying to make the subject look as if a great deal of light is on it? Is the subject turning into or away from the light? Even as you choose solutions the questions go on and on.

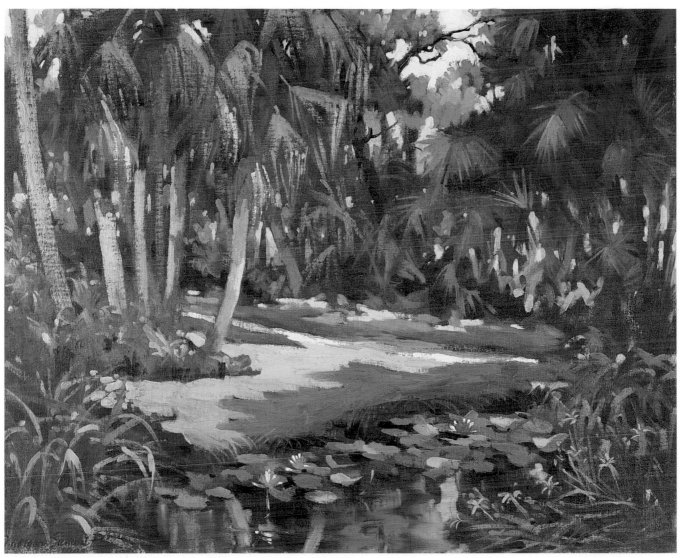

Gleason's Pond, 24″ × 30″ (61cm × 76cm)

The Three Key Elements

There are three key elements that logically determine how you find your color solutions. These are value, intensity and temperature.

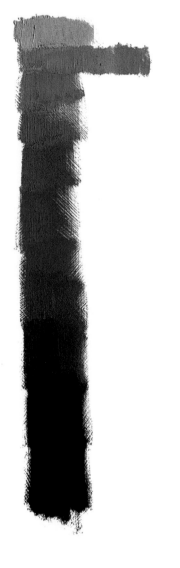

VALUE

In chapter two you learned to attach value to absolutely every color in your painting. By choosing an array and contrast of values, you are able to build form and space. It is worth repeating now: You can create the illusion of form or space only through value. Create values for your colors by adding white to a color to create lighter values and the color's complement to create darker values.

All Color Has Value

In this array of color, notice how I added white to get lighter values and the complement to get darker values. If you need to warm up your light values, introduce another warm color to the white.

A Typical Color Value Scale

The lower values on this scale were produced by introducing the complement to the color and ultimately combining two of the reds from the palette to make the value appear even lower. White was added to make the value lighter. Where the scale appears wider near the top, observe that both white and the color's complement were added to achieve a range of lighter values.

Once you have determined the value, you can begin to establish the range of intensity appropriate to the task. Value and intensity must work hand in hand. Light values support low intensity colors. Conversely, dark values support high intensity colors. Dark values are also capable of supporting any intensity; however, light values are strictly capable of supporting low intensity colors.

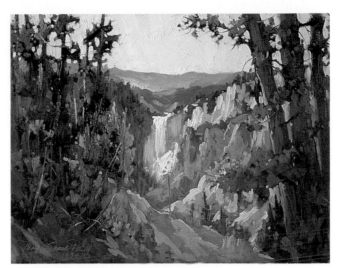

The Falls at Yellowstone, 16″×20″ (41cm×51cm)

Value

Value is generally described in terms of light/medium/dark or high/medium/low. Both sets of terminology mean the same thing. In order to distinguish one area from another, you must contrast the values. Look at these two examples and see how clearly the areas of light, medium and dark value are defined.

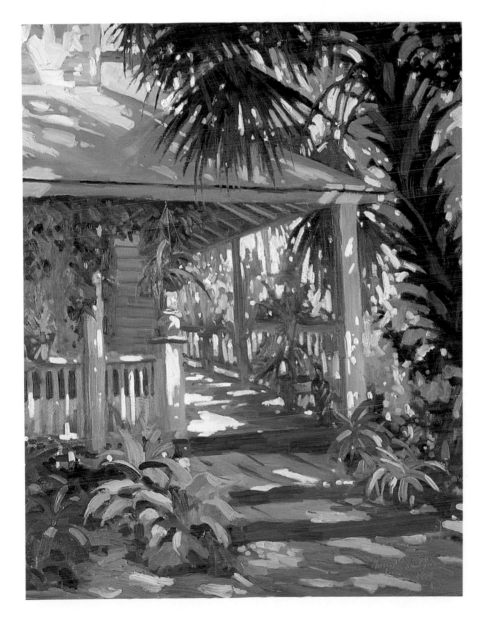

Chris' Porch, 24″×30″ (61cm×76cm)

INTENSITY

Intensity is the brightness, or saturation, of a color. Practically speaking, any color is at its highest intensity as it comes out of the tube. On the other hand, low intensity colors can be either a very light shade, or can be very dark in value. Intensity goes hand in hand with value in order to successfully paint the illusion of light. Likewise, value plays a very significant role in the selection of the right intensity. For example, in a light value painting, where the intensity of a color is too strong in hue, too brilliant, the color will appear to sit on the surface of the painting rather than on the correct plane. Value and intensity must, therefore, be carefully adjusted to support your choice of color and to have it appear to sit on the correct plane.

HOW TO CHANGE INTENSITY

There are three ways to change the intensity of a color: add white; add its complement; or add black. Of these three options, I don't add black often because, for me, it diminishes rather than enhances the potential of color.

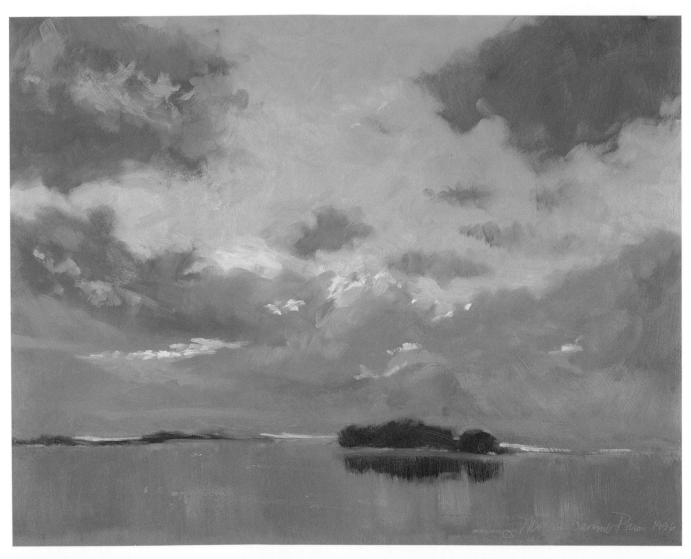

Low Intensity Color

Oslo Area, 16″×20″ (41cm×51cm)

This painting clearly conveys low intensity color. White paint was mixed into all colors that went into the development of the painting. The contrasts are fairly close together; therefore, the contrast of values and intensity are close. That's what produces the overall feeling of light and softness.

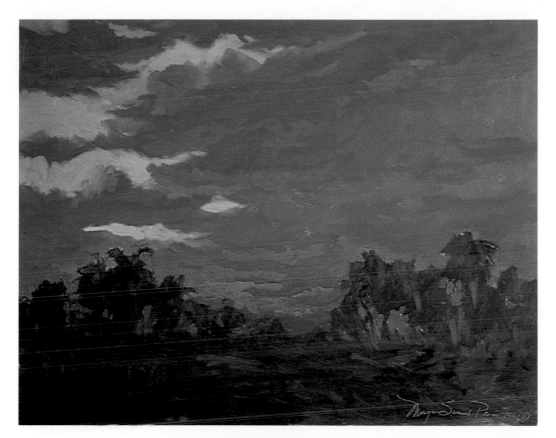

High Intensity Color

In this painting, dark values support high intensity color. To make this work, I first painted the trees very dark. Then I laid in the brilliant color, and lastly, I lightened the value of other colors in the sky and worked toward the desired effect of light. When you work from dark to light, your painting is generally easier to control. Another important feature to point out is that dark values will support any value, but this is not true of light values.

Sundown, 16″ × 20″
(41cm × 51cm)

The Full Range of Values

Most paintings are accomplished in the manner you see here, with a full range of values represented. When you want a color to sit on a distant plane, do not use any intense color because the color will not appear to recede into the distance. In the creation of an illusion, all color is employed in consideration of the plane you are trying to depict. Your study of light on a plane is always at the forefront, so you can easily create the correct illusion.

Grazing, 16″ × 20″
(41cm × 51cm)

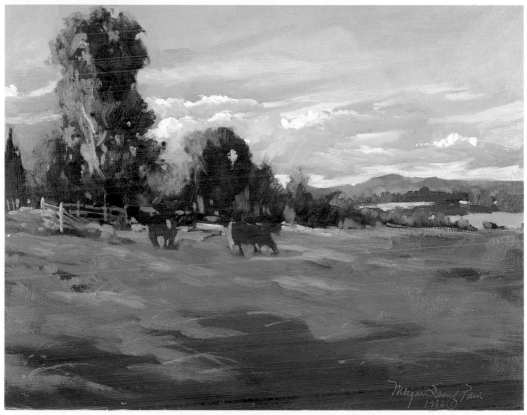

TEMPERATURE

Color temperature is integral to telling the story of what light is "doing." Unfortunately, temperature is often the last element taken into consideration in the color selection process. Should the color be cool or warm? You must be able to show the difference in a form depending on whether the form is turning away from the light, or coming into the light. For the most part, you will find that warming the color as it approaches the light and cooling the color as it recedes from the light is a very common circumstance. However, this is not universally true, and there are circumstances where just the opposite may occur, giving you an object in light that should appear slightly cooler, or giving you an object turning away from the light that should appear dark, but warm and still low in value. Keep in mind, the correct choice is always in comparison to the other colors in your picture plane.

Although we think of color in a dark place as always cool, some colors will be cooler or warmer than others. The principle of capturing these colors must, as a matter of necessity, change to meet the particular circumstance.

Warm white vs. cool white

Warm orange vs. cool orange

Warm blue vs. cool blue

Warm pink vs. cool pink

Warm vs. Cool Colors

Each color in this illustration is shown in comparison to its cool counterpart. Notice how much temperature affects the color.

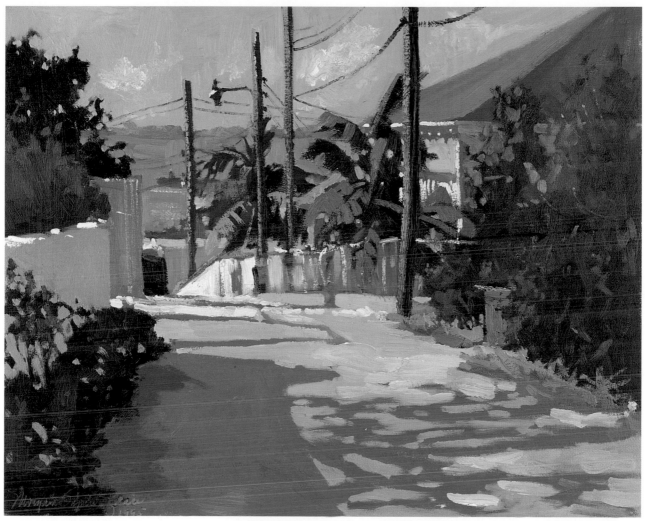

Spanish Wells Street Scene,
16″×20″ (41cm×51cm)

Temperature

These two paintings show the dramatic difference temperature can make. Look how much warmer the painting on top appears to be as compared to the cool painting at right.

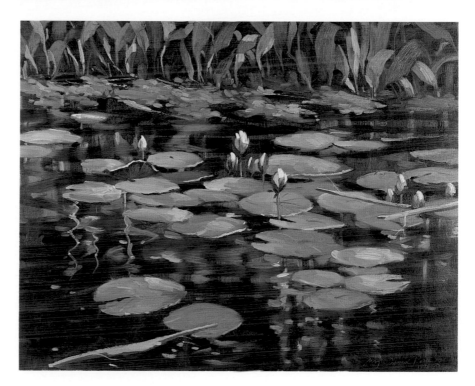

Wednesday at the Lily Pond,
24″×30″ (61cm×76cm)

Light

Whenever you paint, you are in reality painting the effects of light on a specific plane. To paint the light (or rather, the effect of light on a plane), you must use the correct intensity coupled with the correct value to faithfully represent the light. Once you have established your values, use them as a foundation for determining the appropriate intensity of your colors. A guiding principle to remember as you observe light is that the more light you have on a subject, the less color is visible.

Try this test yourself. Take a flashlight and a piece of fabric, let's say red. Shine the flashlight at a distance of about two feet from the fabric. Now slowly bring the flashlight down to the fabric. The closer you get, the less color you will see, to a point where you see no color at all, as you look at the center of the light hitting the fabric. As you observe this process, you can see its effect and better understand how light acts to change the appearance of color.

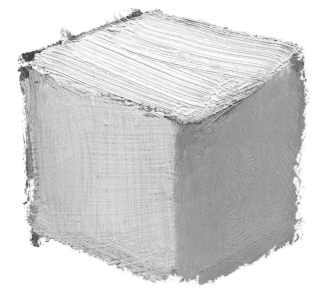 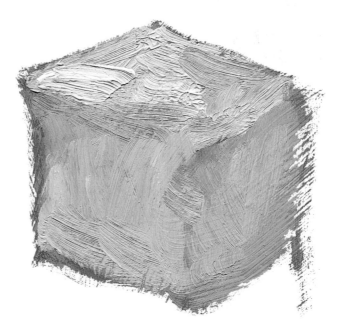

Paint Light in a Simplified Manner

When painting light, state the planes of an object in a simplified manner. The block on the left conveys the message quite clearly as to where the light is coming from and which plane is receiving the least amount of light. The block on the right, however, is confusing because the values are not distinctive for the planes they are describing.

Look at the fabric swatch at top right. The color is nice and evenly distributed. But notice, as the fabric swatch at bottom right approaches the source of light, you start to see less color. Remember that the more light you have on a subject, the less color is visible.

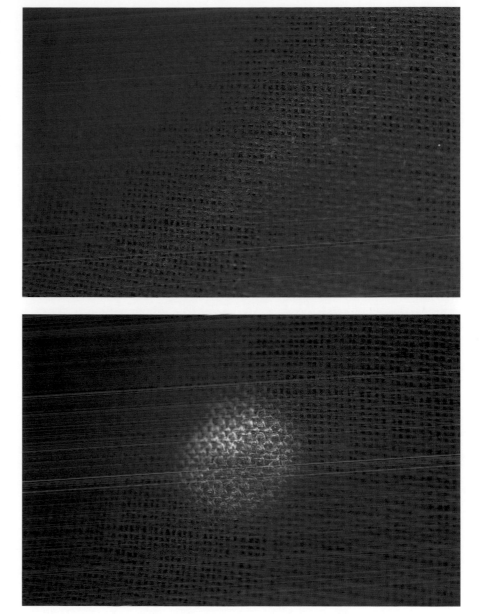

RULES OF THUMB

Here are a few rules of thumb to keep in mind for the development of light in your composition. First, the mass of the sky is usually your lightest area of value because it is your source of light. Second, the next area of light, which is a little darker in value, is any large, horizontal plane of land (a plane which is flat to the source of light will absorb more light, but one that is slanted will absorb less). Lastly, a vertical plane will absorb the least light.

TYPES OF LIGHT AND THEIR EFFECTS ON COLOR

You must become a keen observer of the different types of light and how they affect color. When you pick your colors you must take into consideration the type of light that you are painting. Let's look at some of the varieties of light.

Reflective Light

Reflective light means that one color is literally reflecting into another. When that happens, a lighter color will change because of what is reflected into it. Reflected light may make a color warmer or cooler. That is determined by judging your color in relationship to other colors near it. Also keep in mind that the color of the sky comes into play. When you're on location, every moment can bring a different lighting situation.

Direct Light

Direct light is just that: light that hits an object directly.

Filtered Light

Filtered light is a much softer light created as if light were passing through a screen. You notice a softness to filtered light because the contrast of values is much less in these circumstances. Your edges will be softer because you are working with less light.

Backlighting

Backlighting makes an object in front of the light source appear lower in value. When you put light on the edge of an object to show that it is backlit, the light on those edges will contrast with the darker value and will be warm. That's what gives you the feeling that something is backlit. With backlighting, the values you see will determine the intensity. Anytime you place an object in front of a light source, it tends to appear silhouetted and thus appears darker, with less information and detail. Your presentation of the edges is what makes backlighting interesting.

Cool Light

Cool light is derived from two factors. One is the coolness of the sky as it is reflected onto objects. Remember the atmosphere of the earth is blue. To pick up on the color change caused by the atmospheric condition, painters must cool off their colors. The other factor is the phenomenon that as objects turn away from the light, they appear cooler in comparison to the same object in the light.

Warm Light

Warm light is determined by the type of light source, such as sunlight, candlelight, firelight, lamplight or the color of a light-bulb.

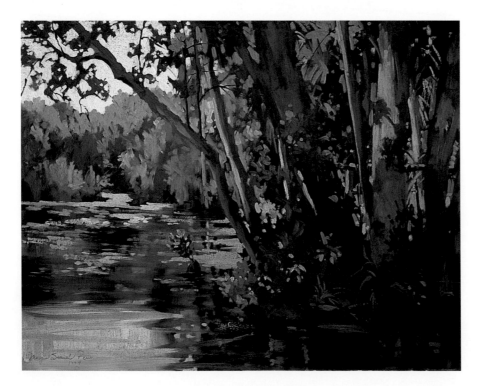

Homosassa Area,
24″ × 30″ (61cm × 76cm)

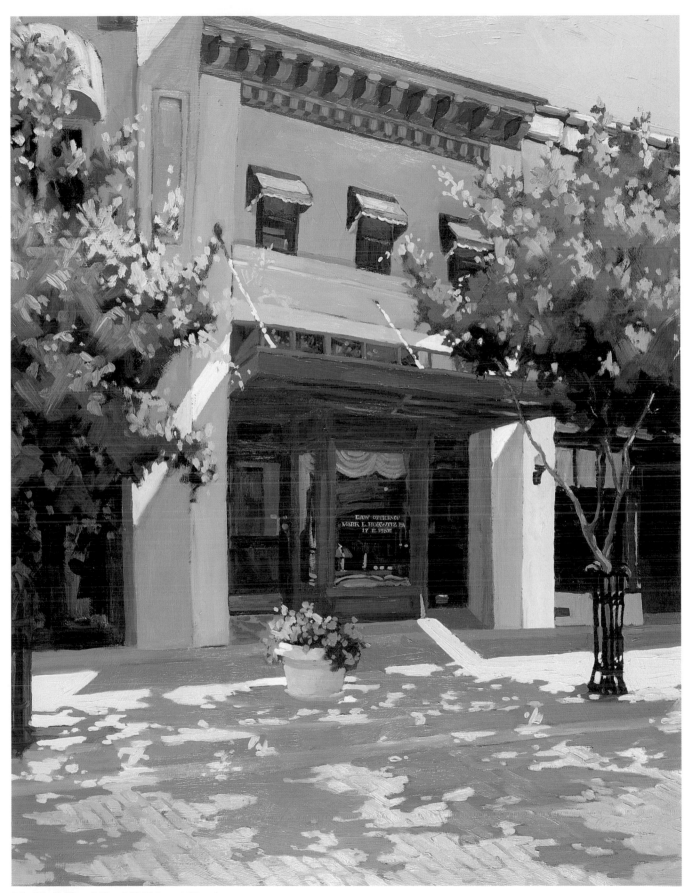

Mark's Office, 30″ × 24″ (76cm × 61cm)

Aerial Perspective Affects Color

Simply defined, aerial perspective is the reduction of contrast in value and intensity as the illusion of space increases in the distance. As color recedes in nature, it gets lighter in value, and the contrasts between values is lessened because you are looking across distance. The further things are away from you, the more atmosphere you are looking through. The blue of the atmosphere makes things look cooler and affects every color. Cool off the colors by adding blue to show the color change caused by the atmosphere. By adding blue to indicate distance, you will establish colors that will correctly appear to sit on a distant plane.

As you factor for aerial perspective, you must retain color options because you may desire to keep warm or cool highlights playing in the distant light. Just because something is in the distance, does not mean you will not see whether colors are warm or cool. But remember that distant warm colors, when viewed through layers of atmosphere, will not be as warm as they would in the absence of that atmosphere. Layers of atmosphere will always alter the appearance of color.

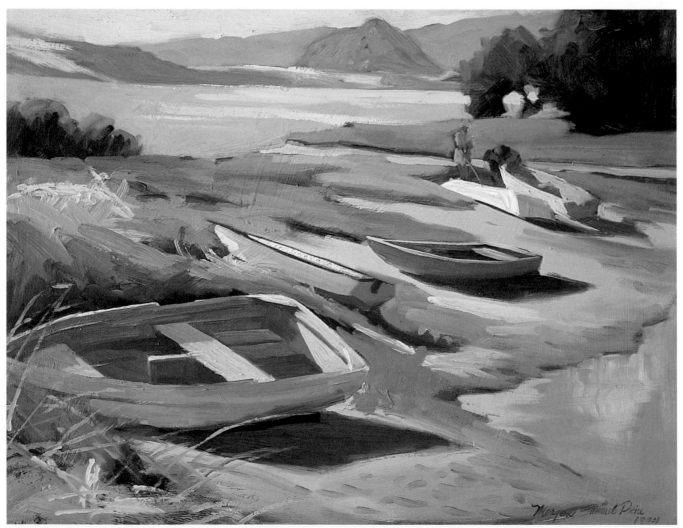

Beached Boats, 16″×20″ (41cm×51cm)

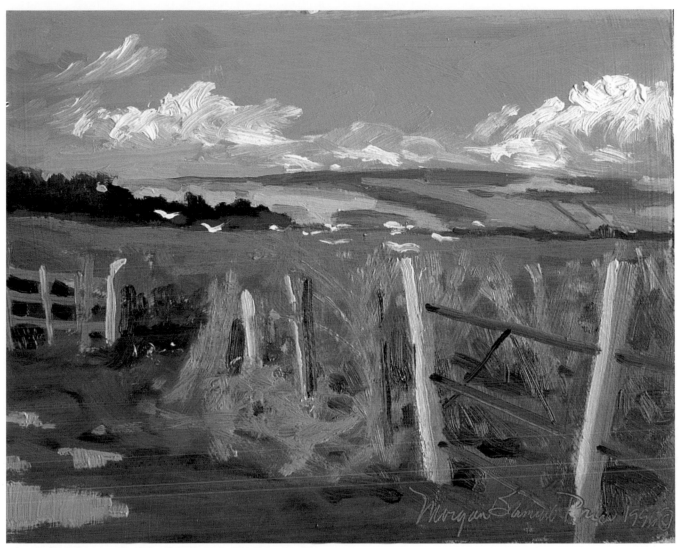

The Highlands, 8″ × 10″ (20cm × 25cm)

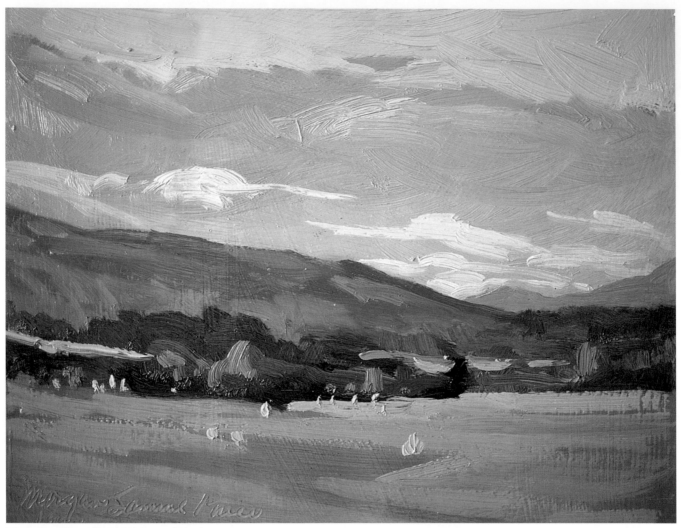

Near Cawdor, 8″ × 10″ (20cm × 25cm)

EXPERIMENT ON YOUR PALETTE

Bear in mind the correct place to experiment with your colors is on the palette, not on your painting. When you want to work with colors and solve color problems, do this on the palette. By the time you work on the painting itself, you should be deliberate and precise with your color selections. As you begin working on your picture plane, you will know in an instant if you have made the correct color choice and can go back to working on your palette as necessary.

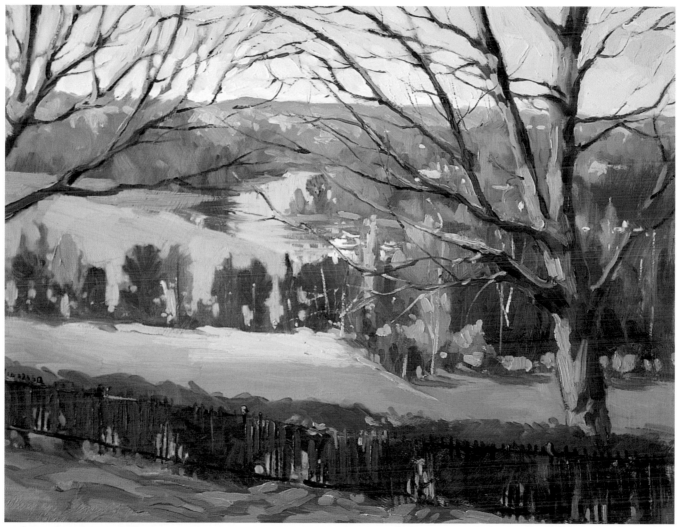

Richmond Park, 16″ × 20″ (41cm × 51cm)

Painting Color and Light Step-by-Step

Painting the still life is an excellent method of learning how to study light and color, because the still life generally provides static conditions of subject and light. From the perspective of studying light, a still life is an easier point of entry for artists striving to build their basic skills and experience.

Almost any object can be used in a still life. Your challenge is to arrange the objects in a manner that leads the viewer's eye throughout the painting. Your setup of contrasts in the painting is one of the primary elements that will help move the viewer's eye around the composition. Your use of line, referring to the edges of your objects, is another key element.

Much of the time your still life will be lit by artificial light. Take advantage of the numerous options available to you in such a situation to create dramatic effects that will capture and hold the viewer's attention.

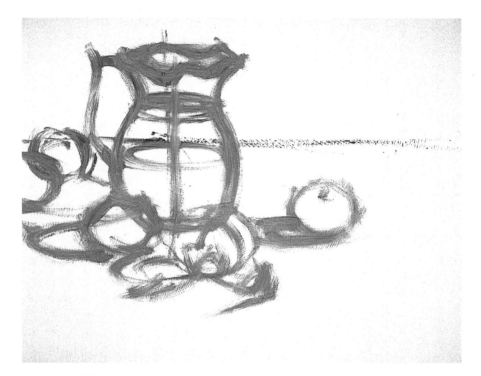

Step 1

Sketch your major forms and establish a reference point from which you can judge proportions and the placement of objects. The horizontal line in this photo serves this purpose. Then determine the full length of the tallest piece in the still life, in this instance, the white pitcher.

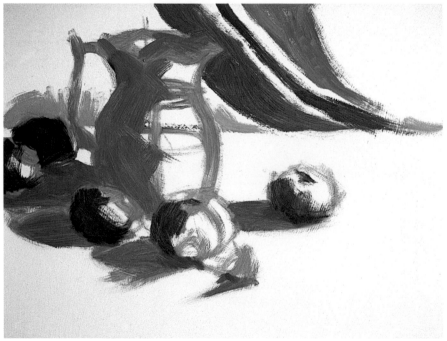

Step 2

Stay in the middle range and block in all positive and negative areas. Don't worry about keeping your work too exact. Your painting should slowly evolve. Simply locate and place the colors. If you use a certain value of a color and it's not quite right, feel free to alter it. Notice how the presentation of the drapery folds behind the pitcher adds a significant design feature.

By using a darker value first and then working your way toward the light, you will make your lighter values much more effective. Rely on a slow building process to create the illusion of light as you gradually develop the lighter values. Notice there is only a suggestion of detail on the pitcher.

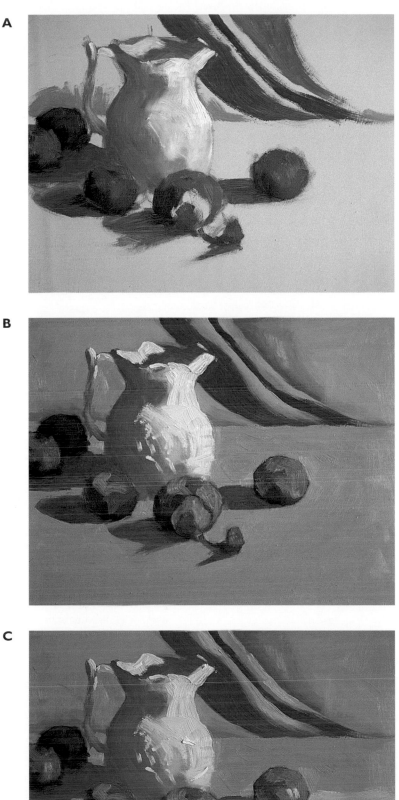

A

B

C

Step 3

As you warm and lighten the value of the color to show the effects of light, build the painting evenly throughout the picture plane. Try to keep the entire image progressing at the same level. This phase is just the start of indicating the form of the objects in the still life and the feeling of space. The key is to maintain control as you develop the painting.

Notice how the presentation of the light in A, B and C becomes fairly well developed as you progress. You should constantly evaluate the contrast of the values throughout the process. Developing the light is a constant exercise in comparing one value against another. The light must be almost fully developed before you consider adding highlights and accents. At this time, check that the large shapes are holding together as you guide the viewer's eye through your painting.

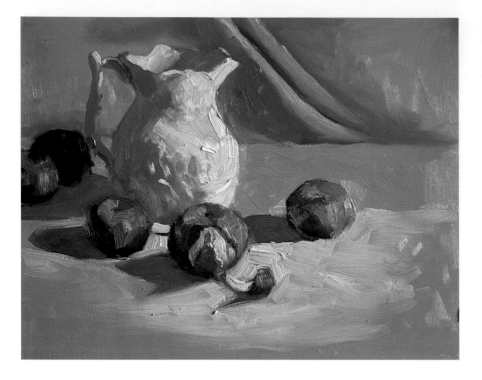

When the relationship of values is completely worked out, you are in position to accentuate the focal point. Here, the focal point is between the pitcher and the tangerine at the bottom left. For the beginner, the choice of focal point is most often a case of repeating what you see, rather than choosing it. As your knowledge base grows, your creative choice expands. Only experience will give you the freedom to choose how to select a focal point and where to locate it.

PRACTICAL COLOR TIPS

1. When you're trying to determine the correct hue of something in your painting, look away from that particular area of the painting and then turn back for a second look. Your eyes will tell you how you see the color and your eyes will assist you in your awareness of which direction you should take your color; for instance, your eyes will inform you if you need warm or cool colors to keep your pick of color appropriate to the circumstances.

2. To refresh your eye for color on location, try walking away from your easel and the scene. Rest your eyes for a few moments and then return to your work for a renewed look at color and better color judgment.

3. Look through an opening the size of a pencil eraser. Judge the value and hue against other areas in the scene to confirm the relationship of the colors. Always keep in mind that color value conveys the best message. Everything else leans on the value.

4. Make a black and white value scale. Take the colors you mix and compare them to that scale. Observe where each color sits on the value scale to better grasp the relationship of color to value and to determine whether you are using the correct value. It is always more important to get the color value right rather than the color choice, since color choice is always subjective.

5. When you view a subject by squinting, remember that the color and the value should appear to be exactly the same. You know you have the right value when you can't tell the difference between the color and the value to which you are comparing it. Achieving this goal is very critical.

6. Take each color in the spectrum and make a value scale by adding white paint to lighten it and by using its complement to darken it. The information you will gain by doing this exercise is immeasurable! To extend your practice, alter these colors by warming or cooling them. Each and every time I mix a color, I go through this mental exercise to improve and master my color effects. Getting the color right requires dedicated, persistent effort.

7. Do a black and white study of your subject to help determine how well you see values and to build awareness of the values you see. By practicing your ability to create a feeling of space in just black and white, you are practicing your ability to judge value and gaining an understanding of your chosen medium.

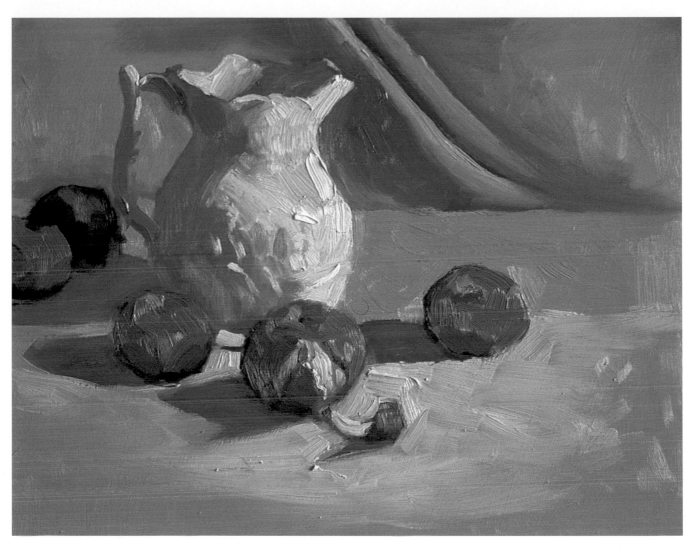

Step 5

In this final step, add the highlights and accents.

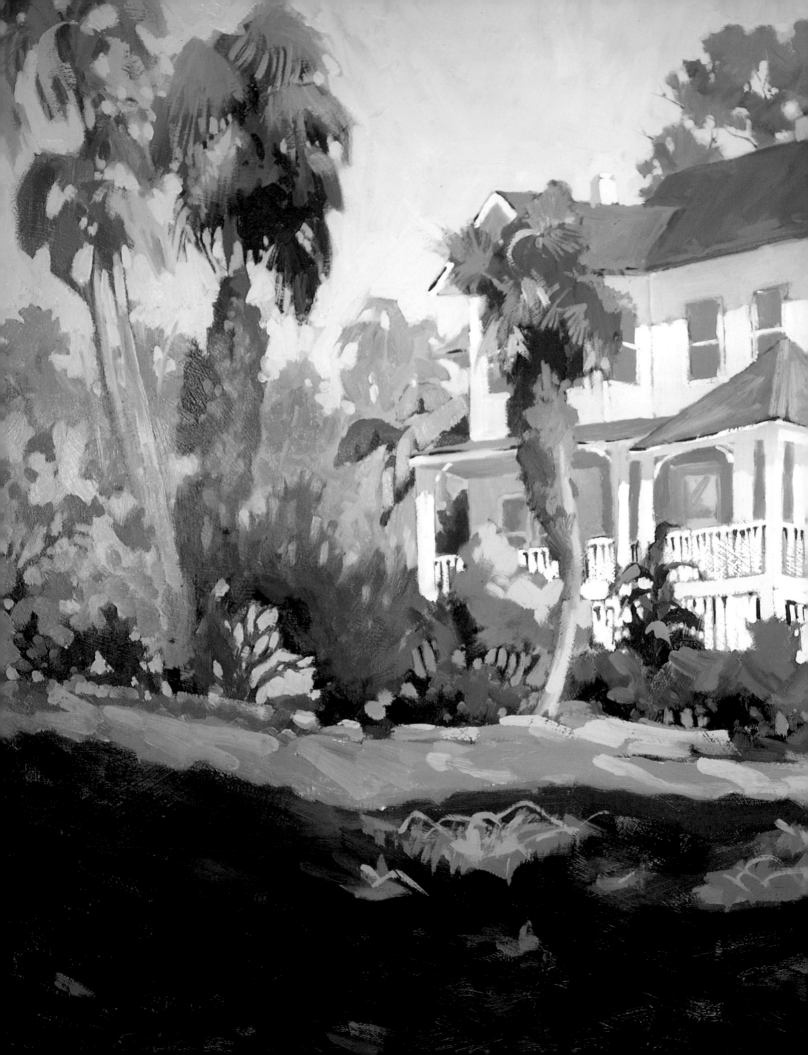

CHAPTER FOUR

Design

Hilltop, 24″×30″ (61cm×76cm)

What Is Design?

Design refers to the method of selecting and placing major shapes and the way in which those shapes lead the viewer's eyes around the picture plane. Whatever you do to alter a shape or change a direction is for the sake of design. Similarly, when you add or delete objects, it should be to meet the ultimate goal of achieving an effective design. When achieved, it captures the viewer's attention by getting him involved and by leading his eyes through your painting.

When you are starting a design, use only three to five simplified shapes and build them entertainingly. In the early stages of your painting, these shapes will lack or only barely suggest a third dimension, and it is important to ensure that they do not compete with one another. Build viewer interest through variety in the shape, edge, line and eventually in the contrast, thinness and thickness of the paint. Attention to design is critical before turning your attention to color, light direction, or before creating the three-dimensional quality of your work. Always remember good design is what captures and entertains the viewer.

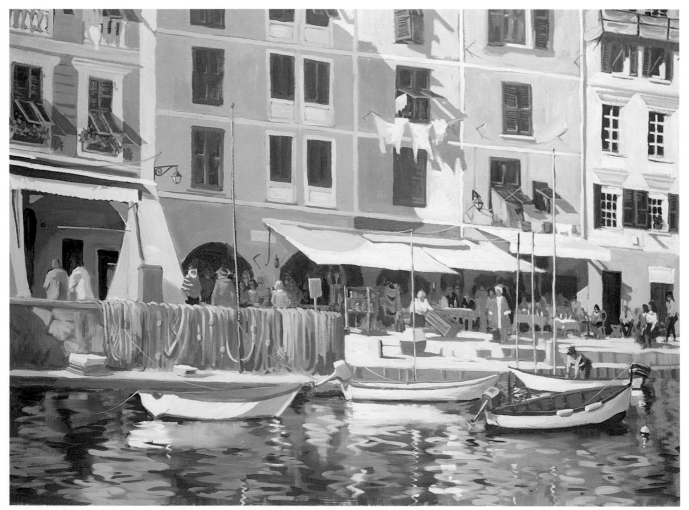

Portofino Facade, 30″ × 40″ (76cm × 102cm)

Shapes

Whatever your subject, as an artist you collect shapes and selectively move them within your picture plane. You should feel at ease to twist, turn and tilt what you actually see. Start first by observing and studying what is physically present before your eyes. Strive to understand the "forms" in nature. This requires a great deal of practice to get really comfortable.

Let nature be your teacher. You will see an infinite variety of shapes, some more entertaining than others. Choose attractive rather than unattractive shapes. Try altering what you observe, using your own creativity to make a good design.

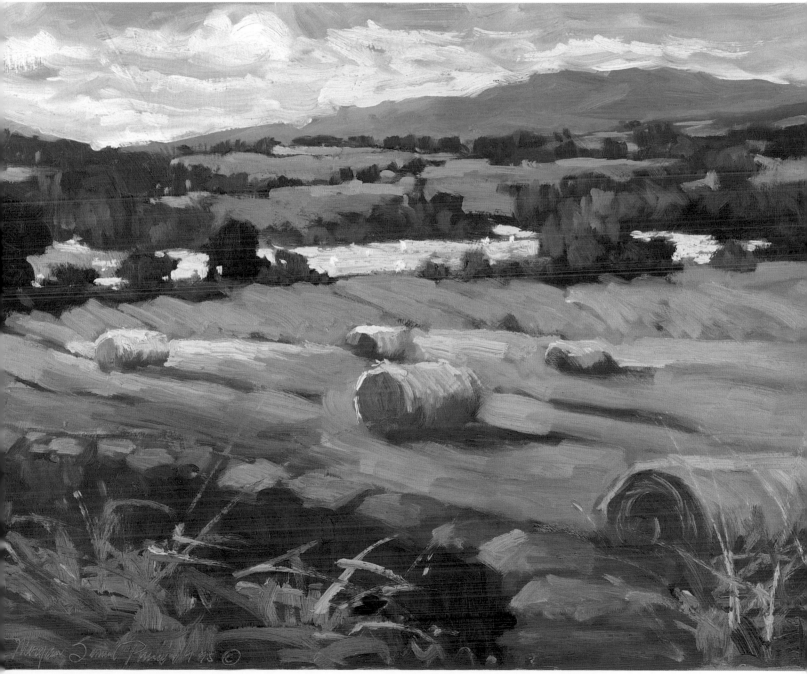

Hay Rolls, 16″×20″ (41cm×51cm)

Design Elements

FOCAL POINT

The focal point is a key design element which is analogous to a film star. It is the strongest element in a work of art, but it is nothing without its supporting cast. The focal point draws your eye naturally to it, but without the interaction of that supporting cast, you end up with an unsatisfying work of art. The focal point must interact with the whole piece and, therefore, need not be overwhelming; it is not intended as a bull's-eye. Think of understating the focal point rather than overstating it.

Your focal point must work together with all other elements in order for a painting to fit together as a whole. For instance, if there appears to be more than one focal point in your work, you are probably trying to squeeze two paintings into one frame.

POSITIVE AND NEGATIVE

For a greater understanding of how your design elements must work toward a whole painting, consider the use of positive and negative space. As you draw a positive shape, whatever it is,

you are automatically creating a negative shape around it. Each aspect is important to design because the viewer sees both the positive and negative shapes at the same time. The restrained artist probably tends to pay a little more attention to the positive shape, but this space requires negative space for completeness.

PERSPECTIVE

Learn the basics about perspective for an understanding of how to construct the illusion of the third dimension in any painting, including still life, portraiture or landscape. A sense of perspective is fundamental to creating a receding line and to presenting the correct proportions as objects are made to recede. Our example shows a day when cumulus clouds have been blown apart and look like dabs of cotton in the sky. The challenge is to paint the clouds with dimensions that make them appear to recede. In order to judge the correct proportion associated with the clouds, you must understand the concept of perspective.

Horizon Line

Position yourself so you are looking directly ahead; this is your horizon line. You will always see the horizon line dead ahead. Your horizon line does not vary; however, your eye level may vary depending on where you start, i.e., sitting or standing at ground level or observing from some other height.

It is critical to determine if you are looking up, or down, at the subject, or if you are looking dead on. Check where you are on a plane in relation to the plane of what you are looking at. Set your perspective according to how you are viewing your subject and remember all objects in your sightline are governed by this perspective. This process is universal whether you are painting a still life, landscape or portrait.

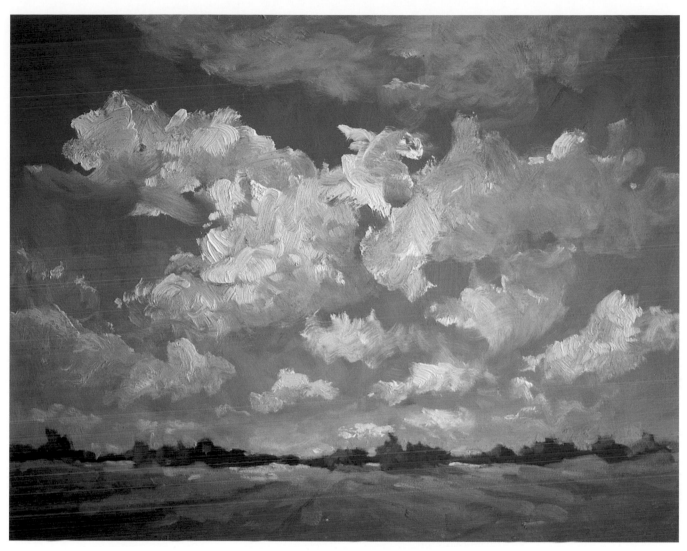

Clouds in Perspective

In this example of clouds, start by radiating straight lines from a central point on the horizon line. Clouds as objects appear smaller as they recede from your viewpoint, just as would other objects, such as a building, road or fence.

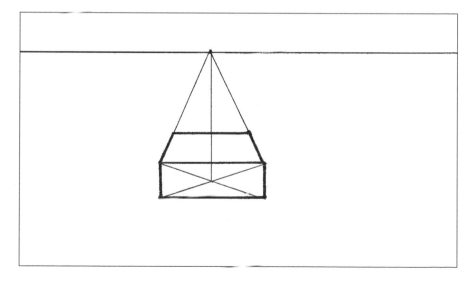

One-Point Perspective

In one-point perspective, everything from above and below the horizon goes to just one vanishing point. In this drawing, the size of the object is arbitrary and is drawn back to the horizon line, demonstrating that receding lines converge as they recede away from the viewer.

Two-Point Perspective

There are two vanishing points in two-point perspective. This drawing shows a box drawn below the horizon line and a building on a hill above the horizon line, as if you were looking up. Objects below the horizon line appear as if you are looking down on the subject and can see three sides: the top side, one side receding to the right, and one side receding to the left. When looking up, as at the house in the drawing, you would be able to see the bottom rather than the top of the box.

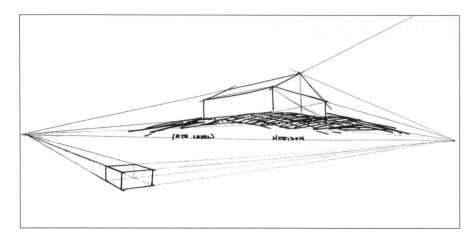

To observe two-point perspective for yourself, place a box on a flat plane. Facing the box as if at a distance, use a straightedge to establish the horizon line. Then use the straightedge to align the bottom of the box with the horizon line. In this illustration, lines from the top and bottom of the box extend to the vanishing points on the horizon line. Observe

that the right side of the box is drawn to the right vanishing point where the top and bottom appear to converge. Because all lines are parallel in perspective, the same principle governs lines converging at the two vanishing points, whether the observer looks up or down at the box.

You can readily find the center of any flat plane by drawing a diagonal line from corner to corner of that plane. Dead center is where the diagonal lines intersect. At that point, draw a perpendicular line through the intersecting lines. This establishes the center of any given line. (This is helpful for finding the peak of a roof or the center of a window!)

Using Perspective

After you have established the horizon in your composition, establish the various levels of the different planes so that you can set the buildings into the plane in the correct perspective. The road is constructed in one-point perspective on rising and falling planes, and the buildings are constructed in two-point perspective.

A full grasp of perspective requires the rigorous practice and drawing experience afforded by a drafting class or other formal study. Invest the time in a hands-on effort to use the principles and drawing skills associated with the study of perspective. You must understand what perspective is before you can convey it.

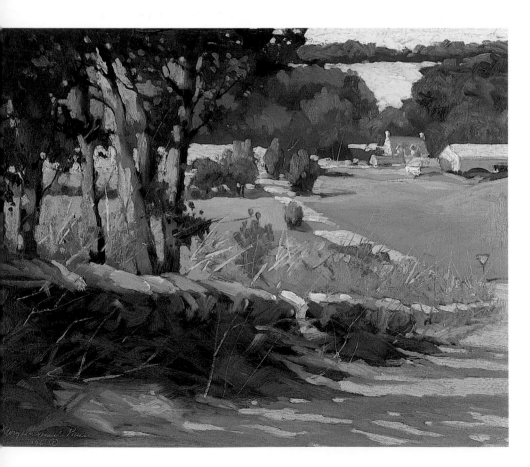

On the Road to Cantry, 24″ × 30″ (61cm × 76cm)

Design Flaws

There are certain problems which you should aim to avoid; these are well-established flaws which are, at best, difficult to make work. Look at these following illustrations as examples of what not to do. I am indebted to Carl Cogar for his insights and patient tutoring in this area.

Don't divide your picture plane in half, either vertically or horizontally.

Don't draw diagonals across your picture plane.

Don't draw an object too large for the frame; they will crowd the frame.

Don't draw objects too small for the frame; they will get lost in the frame.

Don't put two similar shapes on either side of the picture plane so that the shapes appear to fight for dominance.

Don't create two totally different shapes, each with the same volume; the shapes will appear to fight for dominance.

Don't create a line that runs parallel to the edge of your picture plane; this will create the effect of cutting off that area of the painting and make it useless.

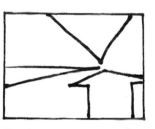

Don't create arrows to draw attention to a particular location in your drawing; this is poor design because the eye gets "stuck" in one location rather than moving around within the whole of a painting.

Don't end one shape on the edge of another; this also stops the eye from moving around the picture plane and tends to lock the eye of a viewer to just one location.

Don't arch your work out of the frame; the eye will be distracted and follow the line out of the drawing.

Don't allow parallel lines to create conflicting effects; this can be static and boring.

Don't cut off a corner.

A Gallery of Design Notes

Look over these paintings and compare them to the simple line drawings which illustrate how the major masses in each composition are put together. Think of the design flaws you learned earlier, and note how these works avoid those pitfalls.

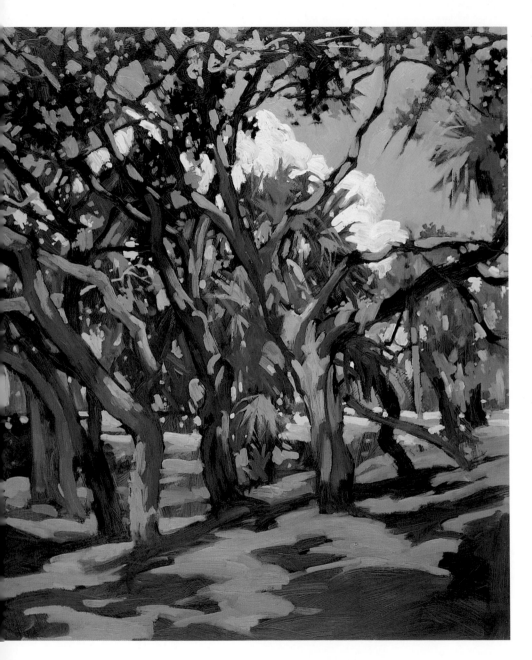

Decide Where You Want the Eye to Enter

A key factor in establishing design is deciding where you want the viewer's eye to enter the painting. Also ensure that you don't create an obvious exit which will lead the viewer's eye out of the picture plane. Notice how the shadows move you into this painting and draw your eye up the tree trunks into the sky.

Sandfly West by Northwest, 30″×24″ (76cm×61cm)

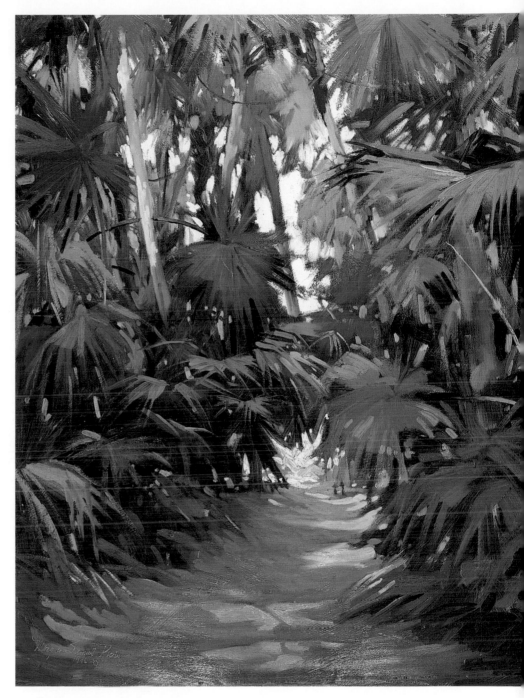

Light Creates a Lacy Pattern

This more complicated design centers on the lacy pattern created as light shines through the foliage. A second large shape is formed by tying together all the middle to lower values including the fronds, the shadows on the fronds and the shadows on the ground. (The pattern of the path leads the viewer's attention into the scene with a combination of hard and soft edges.) Notice that the edges of each shape are important to the overall effect and must be interesting in themselves.

McKee Jungle Garden, 30″×24″ (76cm×61cm)

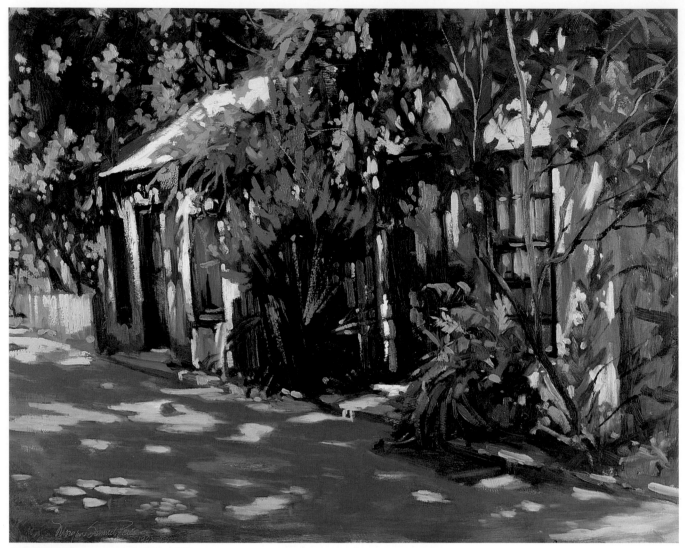

Side Street St. Augustine, 24″ × 30″
(61cm × 76cm)

Use a Dappled Effect

A dappled effect is accomplished by first sketching the building and then laying down the lace pattern of foliage and shadow. The strong diagonal movement from the lower right is complemented by the way the shadow pattern on the ground intersects the building. The intersection of line and shadow stops the eye from running off the picture plane.

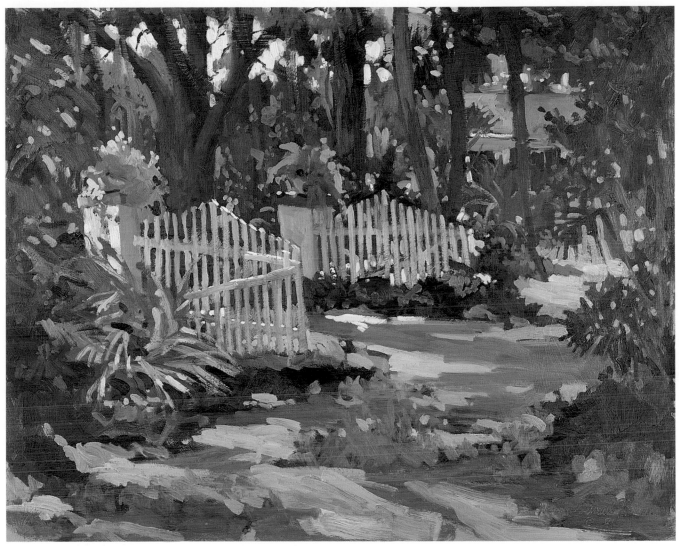

Old Eau Gallie, 24″×30″
(61cm×76cm)

Use Angular Shapes

This painting, full of very angular shapes, entices you along the road and through the entry of the picket fence. The use of contrast draws your eye and is most pronounced at the foot of the gate.

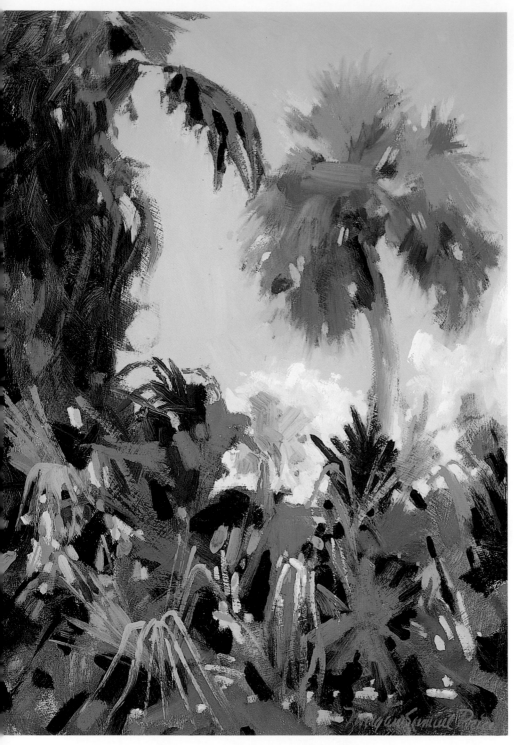

Construct Change and Variety in Your Edges

All the foliage in this landscape forms one large, rich, dark shape which contrasts with the lightness and airiness of the palm. The drama and appeal of this painting depends on constructing change and variety along the edge of the foliage to lead the eye up to the palm. The crux of the design is this edge.

Sabal Palm, 16″ × 20″ (41cm × 51cm)

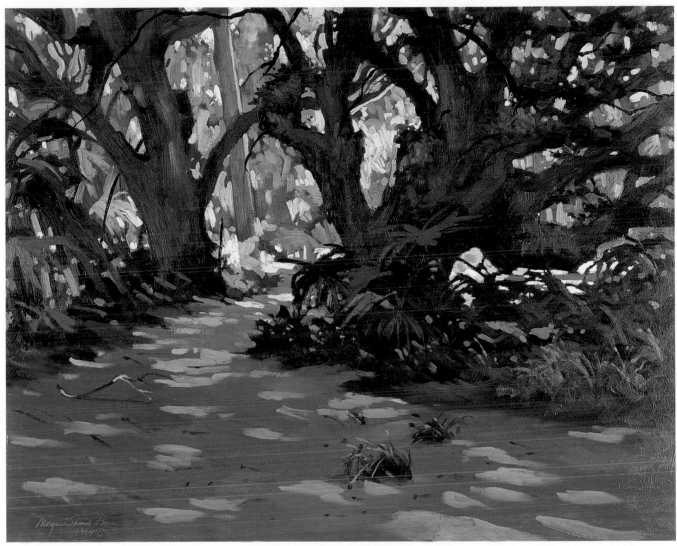

Sandfly East, 24″×30″ (61cm×76cm)

Use One Large Shape

The silhouette of these massive trees forms one large shape of middle to dark values laid over the lacy pattern of the background. The background is a symphony of light and activity while the road is just a secondary feature.

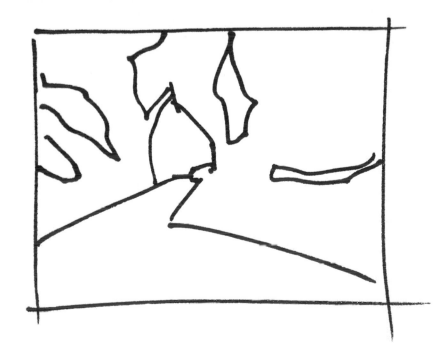

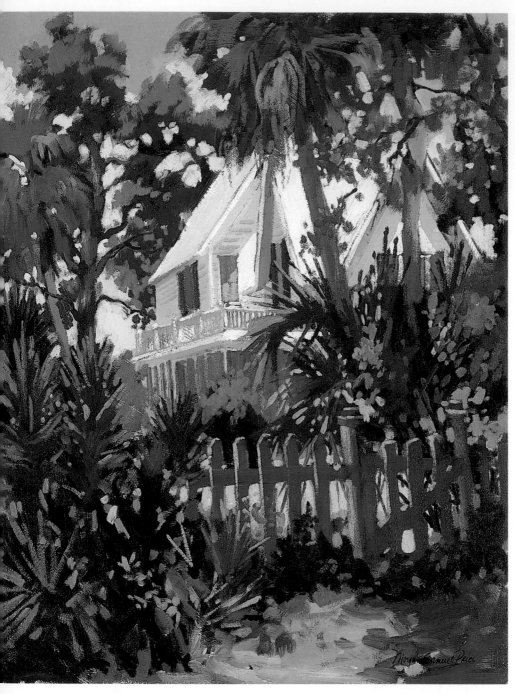

Keep Your Shapes Simple

Your eye pauses in front of the fence before the strong contrast beyond it pulls you into the middleground and on to the house. Large, simple shapes lead you through the picture plane. For example, all the shrubbery in the foreground is one large piece tied together by subtle contrast, soft edges and the use of middle values. Bathed in light, the soft shape of the house is a natural resting place and holds your attention.

Ellis Home on Old Settlement Road, 30″×24″ (71cm×61cm)

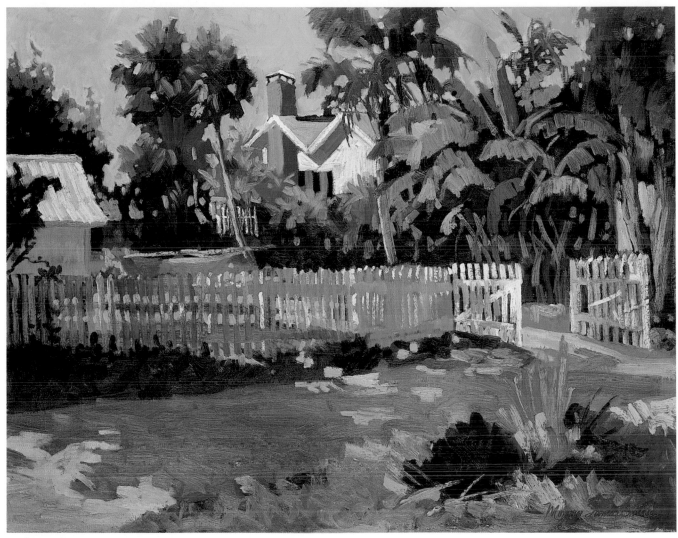

Light on the Fence, 24″ × 30″
(61cm × 76cm)

Use Value to Move the Eye

This simply constructed fence demonstrates how you can use patterns of contrasting value to create interest and move the eye. The half-dark area on the left changes into an area of light on the right and pulls the viewer's attention to the entry. Notice how the light within the shaded area has been given a shape of its own and constitutes a design with a design.

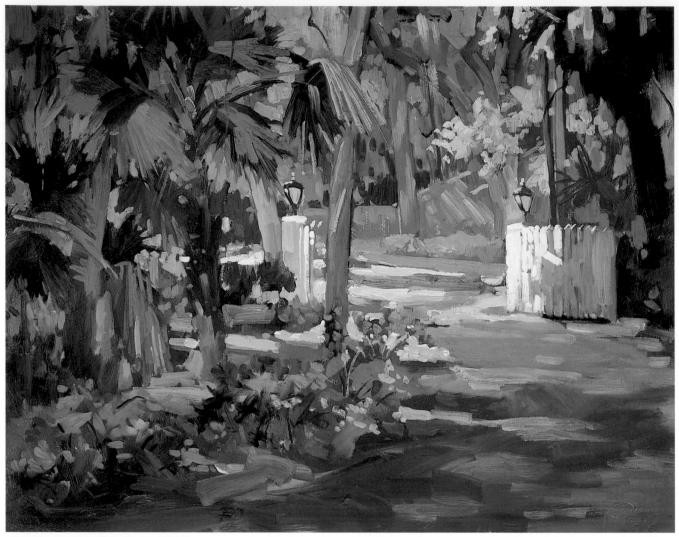

The Entry, 24" × 30" (61cm × 76cm)

A Tunnel Effect

The curving road and the pattern of light on it move your eye up to the entrance. A tunnel effect of dark value surrounding the entry pulls you through the gateway.

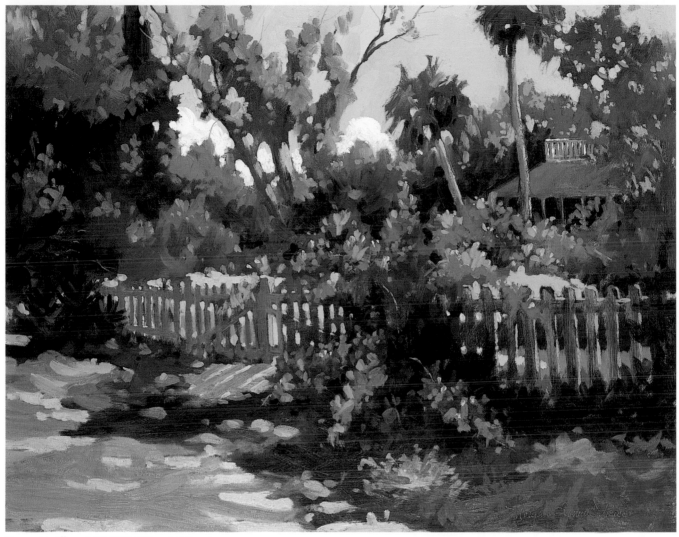

Bougainvillea, 24″ × 30″ (61cm × 76cm)

Guard Against Competing Shapes

The cascading form of the bougainvillea retains interest as long as the length, weight and shape of its tendrils do not compete for attention. The key is to guard against creating competing shapes within the bougainvillea.

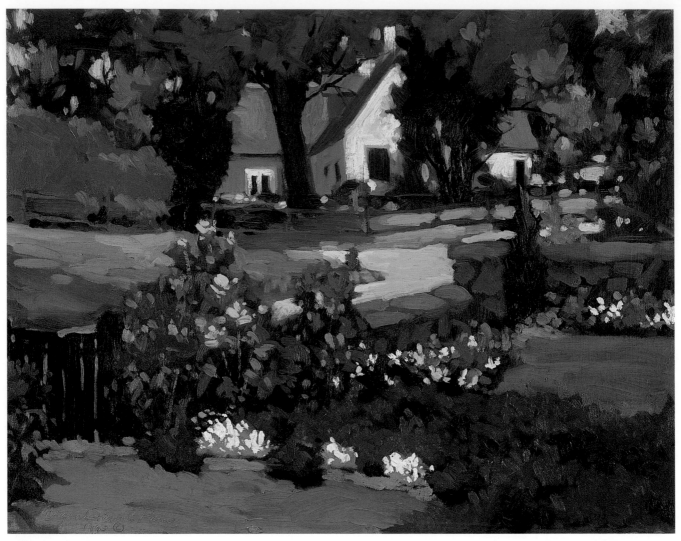

Salvias and Roses, 16″×20″
(41cm×51cm)

Simple, Restful Space

The color and activity of the flowers are surrounded by simple, restful space. After engaging the flowers, your eye follows the diagonal movement of the road.

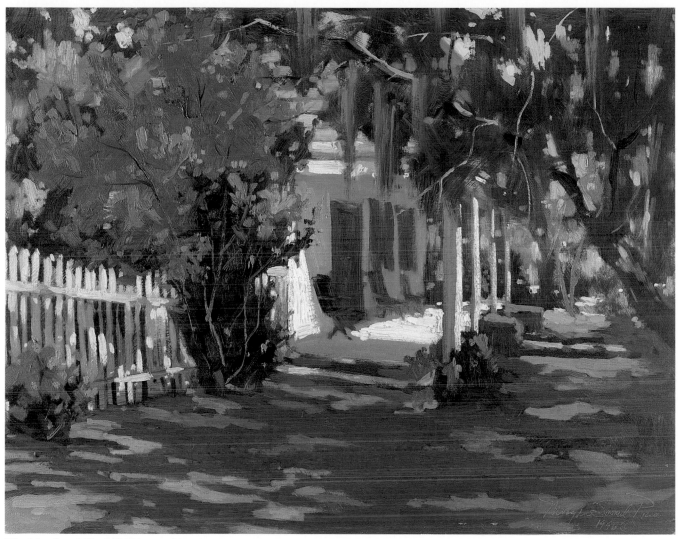

The Myrtles, 16″×20″ (41cm×51cm)

Create a Sense of Motion

Your eye fairly skips along the fence, up the stairs and across the porch. This sense of motion is reinforced by the tunnel effect created by the shapes placed around the porch. Notice how it is ringed by the form of the shrub at the side of the house connecting with the overhanging live oak and the shadows below.

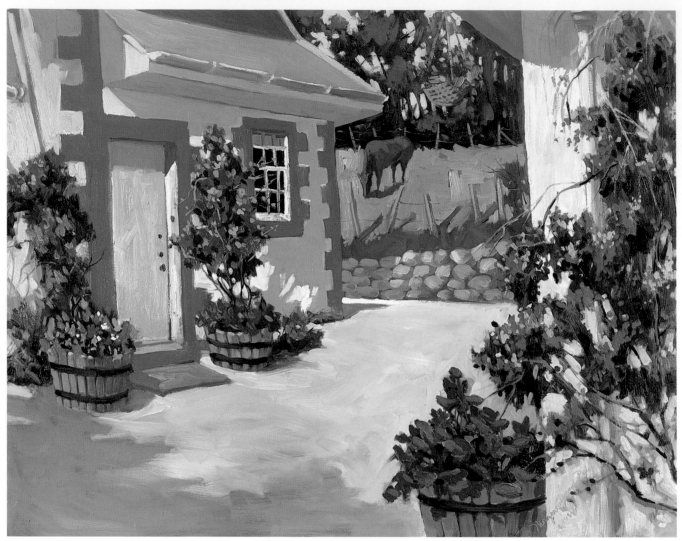

Cantry House, 24″ × 30″ (61cm × 76cm)

Use Shadows to Break Up Hard Lines

The vertical shapes on both the left and right were lined up along the edges without lopping off the sides of the picture. The shrub and shadow pattern on the left break up what would otherwise be a hard line and lead your eye to the first flower barrel. Your eye moves across the foreground shadow to another flower barrel and climbing plant on the right.

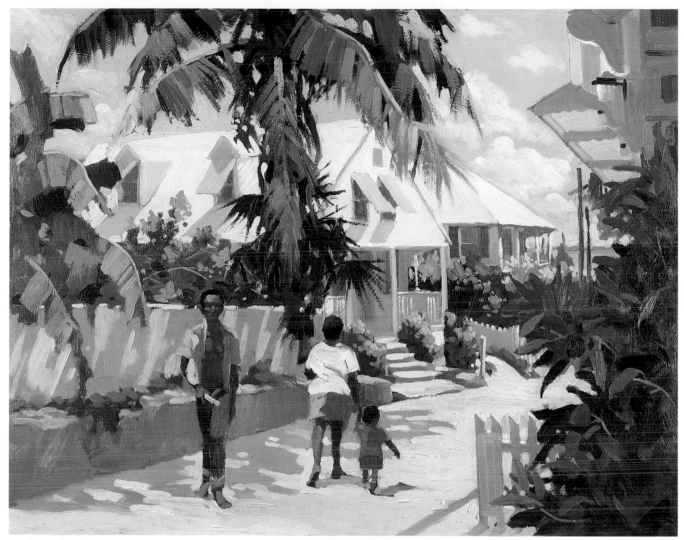

Harbor Island, 24″ × 30″ (61cm × 76cm)

Use Distinctive Shapes

Each major shape in this composition is quite distinctive and each is massive. Here's how to read this design: The figures, wall and major palm tree are one building block. Another large building block along the right edge includes the fence, crotons and architectural features. The sky, house and road form a third major block.

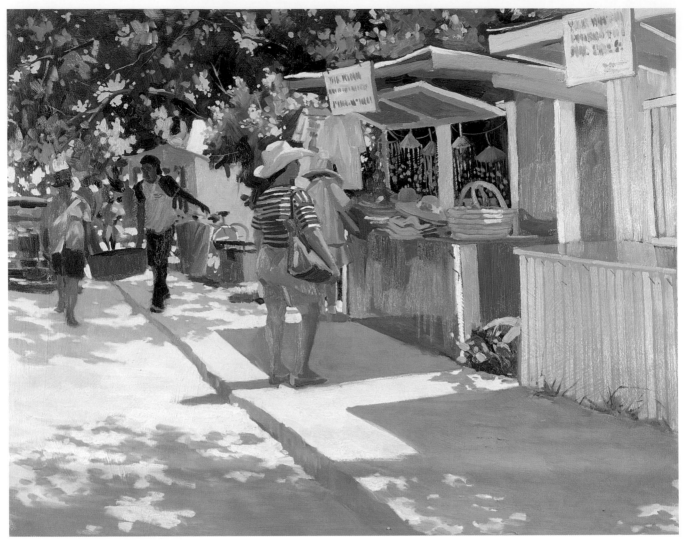

The Market, 24″ × 30″ (61cm × 76cm)

Diagonal Movement

Your attention is pulled into this scene by the diagonal movement from the right. It is a closed landscape framed by the trees behind the architecture, the car and the figures in the background. The sidewalk exists near the corner on the bottom right but is still an appropriate design because it is not actually centered on the corner. Similarly, the exit made by the roof line in the upper right is also a correct choice.

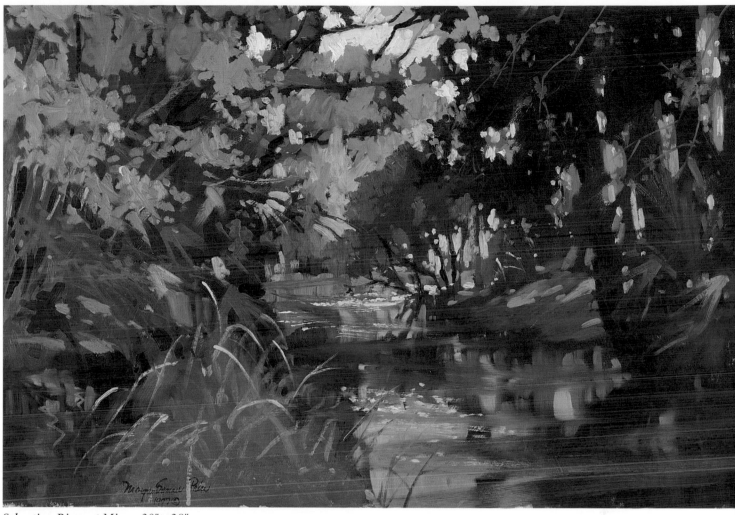

Sebastian River at Micco, 20″×28″
(51cm×71cm)

Keep the Eye Moving

This scene works with the river at its center and is not impaired by having the dominant shapes meet in the middle. The light values through the grassy area and in the reflections along the water keep your eye moving through the picture plane.

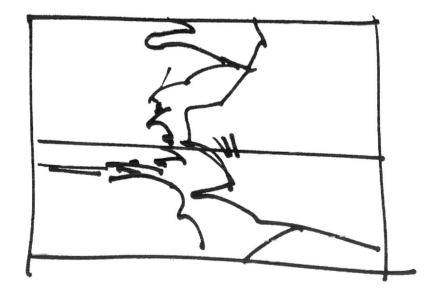

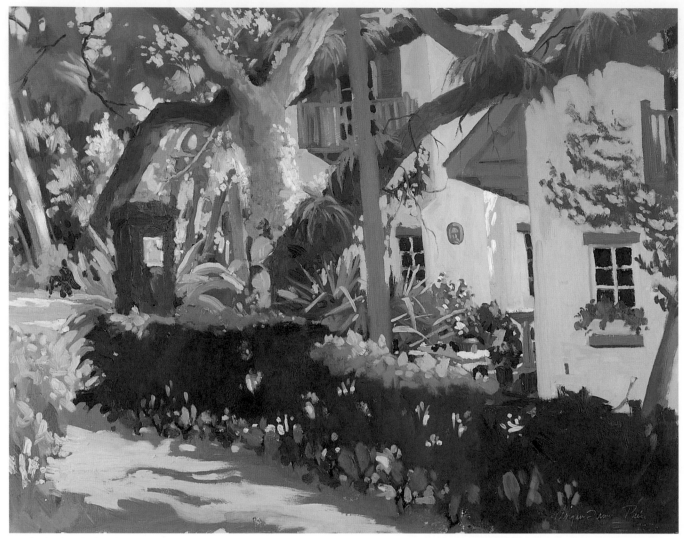

Orchid Island Sketch, 24″×30″
(61cm×76cm)

Feel Free to Change Things

A real-life tableau is frequently just the starting point for a well-designed landscape. Here a variety of trees and plants were relocated to enhance how this home and grounds appear in the painting. Notice how the ground shrubbery and spread of ivy on the wall at the right pull a large, vertical shape into the picture plane.

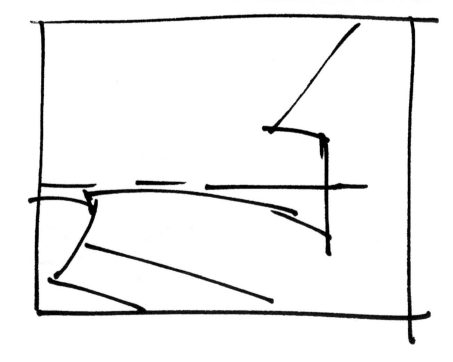

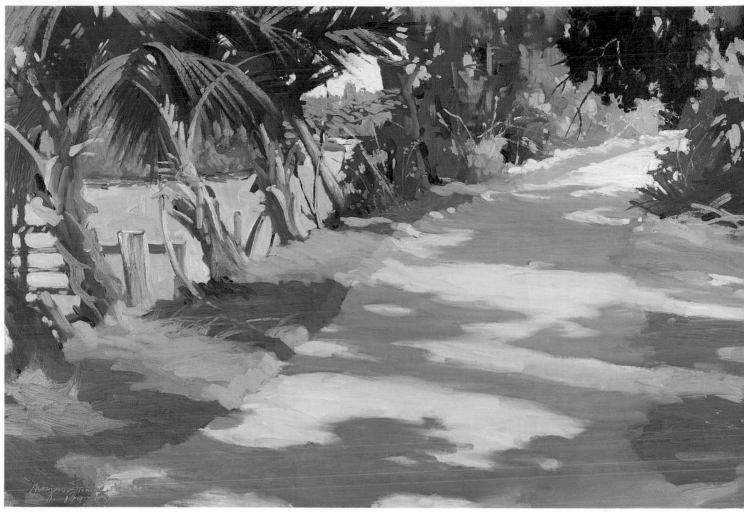

Jungle Trail III, 20″×28″
(51cm×71cm)

Use Shadows to Complement Movement

The strong diagonal movement of the river and the road is complemented by the horizontal pattern of the shadows. In the upper right corner, the flat, dark shape is designed to create a greater sense of space.

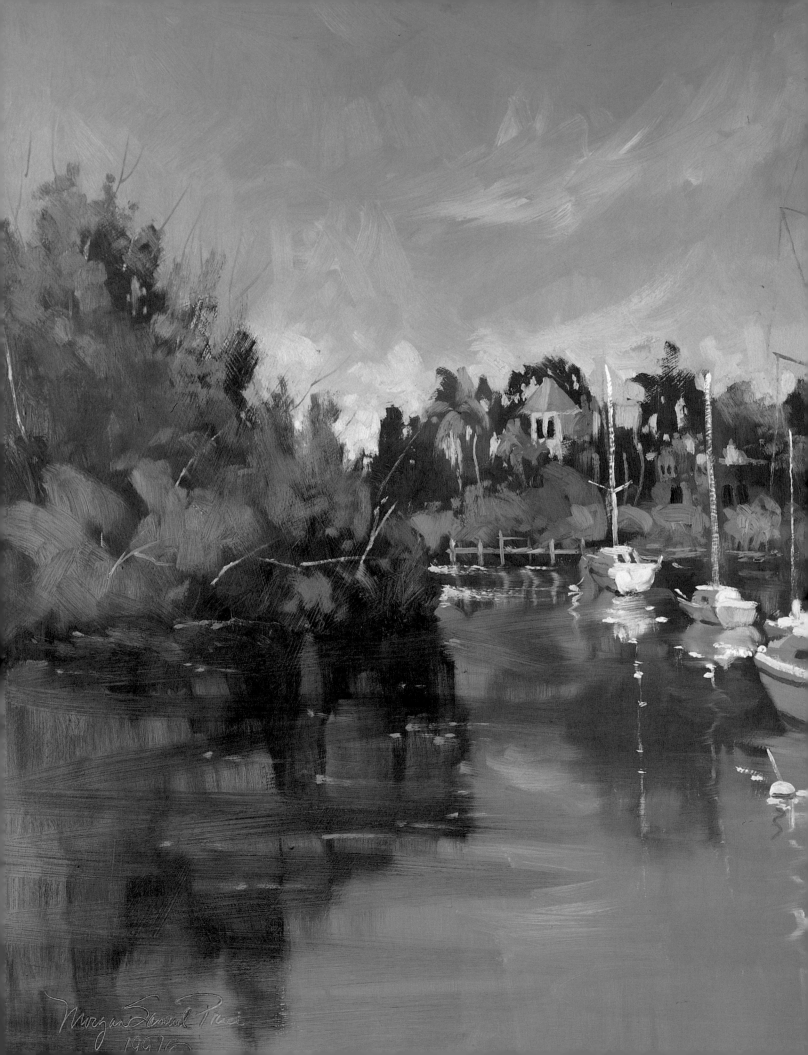

Morgan Samuel Price
1991

Putting It All Together

River View From Jungle Trail, 24″×30″ (61cm×76cm)

How to Build a Painting

There are basically five phases you go through in the development of a painting. They are:

1. Design the major masses.
2. Block in the painting in the middle value range. For example, on a scale of 1 to 10, paint within the value range of 4 to 7.
3. Begin to paint the direction of the light.
4. Continue to develop the form and feeling of space by creating more contrast.
5. Add highlights and accents.

DESIGN THE MAJOR MASSES

Start your painting with the design of the major masses. Generally speaking, a typical painting is comprised of three to five major shapes, but that may vary. Try to keep the major masses as simple as possible. Always keep in mind

that the design is the major technical element that holds the painting together, orchestrates the movement throughout the painting and separates the good artists from the bad.

Experiment with different ideas as you design your piece. Change your view. Change the lighting. There are many options. Establish a reference point to help you to indicate placement of things in your landscape or placement of elements in your composition. For example, in landscapes, you always need to establish a horizon line. The horizon line is dead ahead, and though your eye level may change as you change your viewpoint, the horizon line remains constant. Once it is established, all you need to do is look at the base of all the objects in your landscape

and place them in relationship to the horizon line. In a still life, indicate where the back line of the table top (or whatever your objects are arranged on) would be. Look at that line, and then judge the bottom of each object that is resting on the surface in its relationship to that initial line.

BLOCK IN THE PAINTING IN THE MIDDLE VALUE RANGE

Loosely stated, blocking in is the application of paint, generally thin in its consistency and rather flat in appearance, to roughly indicate major shapes. It is the initial step of painting the picture plane. The brushwork is generally spontaneous and not as highly structured as it will be when you are beginning to describe the direction of the light. Your color should be in the middle value range no matter which color you are using. And though it may

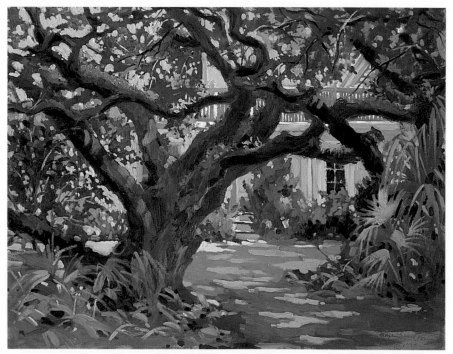

Sandfly East, 24″ × 30″ (61cm × 76cm)

> **TIP**
>
> Here is one good method to judge proportions. Hold the brush in a perpendicular position in front of you at arm's length. As you eyeball the tallest mass in your composition, line it up against the end of the brush handle. You are now using the brush handle as a rough measuring device to determine the necessary proportions. Continue this measuring process to complete the placement of all major masses.

sound like it, the overall process of blocking is far from a coloring book approach and in no way will you be "coloring within the lines." Rather, think of it as creating the skeleton of your subject to which you slowly describe how the light is affecting the plane.

Work Your Color While Blocking

To avoid chalkiness or muddiness, the intensity of your colors must be correct for the value that you have chosen. If the color appears chalky, the simple solution is to put more pigment back into the color you initially mixed on your palette. If your color becomes too muddy from adding too much of the complement, go back and add more of the color with which you started. This process is a constant jockeying among the pigments, adjusting as necessary, to depict the illusion you are trying to create. In oil painting, always keep in mind that it is generally much easier to build from dark to light than it is to build from light to dark.

BEGIN TO PAINT THE DIRECTION OF LIGHT

After you have established the middle value range, begin to show from what direction light is coming. To show light hitting an object, lighten the side of that object where the light would hit. As you lighten, do not add too much white paint to your colors too quickly. Let the painting evolve slowly. If something doesn't seem right, feel free to alter it.

In landscapes, your only source of light is the sky. But different types of landscapes require you to

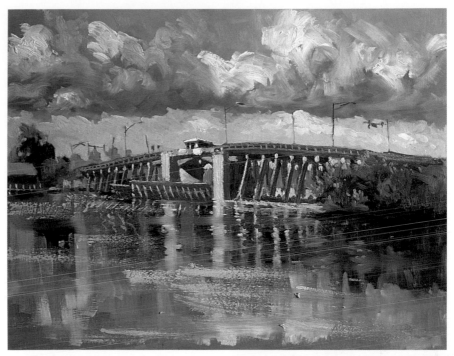

Barber Bridge, 16″×20″ (41cm×51cm)

treat light differently. In an open landscape, one where the sky is not totally covered by trees or objects, you may block in the sky first. But in a closed landscape, where you view the sky as if peering through lace, you'll want to paint in the trees first.

Sometimes, you may wish to block in your sky in a slightly lower value than it will appear at the completion of your painting. This provides the opportunity to lighten the value if necessary. There are other times when your first choice is the correct one. Don't hesitate to stick with it.

Once you have addressed the direction of your light source, you will find that you have begun the process of developing the forms within the painting and how they appear in their spatial relationships. Once you have established both the middle value range and the major source of

Daisy Day, 16″×20″ (41cm×51cm)

light, you're in a position to correctly compare and select all the other values for your painting. Now you will be able to best judge if a given value is appropriate to the task. You'll be able to more successfully place each succeeding value. This method of comparison is vital to getting the values right. Remember that the development of light is a deliberate process. Do not rush.

CONTINUE TO DEVELOP BY CREATING MORE CONTRAST

Now it's time to begin to lighten the values as necessary to show contrast of form and to create a feeling of space. Remember, if you cannot tell one area from another, the feature holding you back from the desired illusion is the lack of contrast of value. Build your painting gradually, and work slowly and deliberately to create the required contrasts. Move around the picture plane and develop all areas gradually. For instance, it's not a good idea to finish, let's say, all the activity in the middle ground before moving to another area, for instance, the foreground. It's important to work all areas simultaneously while keeping the development of all elements at the same level of completion. Paint evenly. Try to keep the entire image progressing at the same level. The key here is to maintain control.

Throughout the process of creating your painting, and especially as your presentation of the light becomes fairly well developed, constantly evaluate the contrast of the values. Developing the light is a constant exercise in comparing one value against another. The light must be almost fully developed before you consider adding highlights and accents. At this point the large shapes should be holding together. Your eye will move in them and through them because of your contrast of values. The major shapes need to remain a constant. If you place them in a certain location at the beginning of your painting, they should be there at the end.

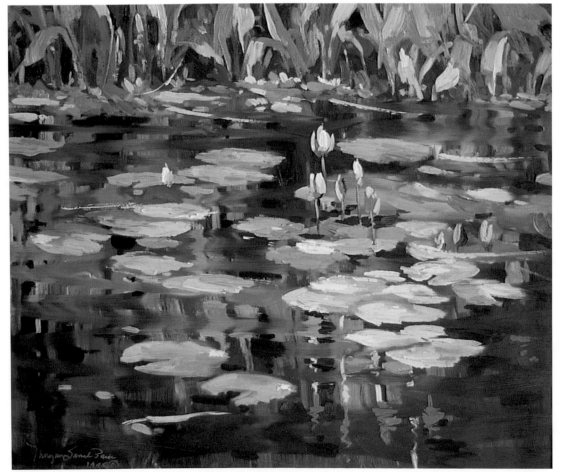

Wednesday at the Lily Pond, 24″ × 30″ (61cm × 76cm)

ADD HIGHLIGHTS AND ACCENTS

The final stage is to place your highlights and accents. Highlights refer to the lightest lights in your painting. Accents, on the other hand, are the darkest darks and involve small, very dark brushstrokes to accentuate contrast. Highlights and accents are used where you feel you need to heighten the contrast or wherever you feel they will enhance your painting.

Emphasize your focal point by increasing the contrast. Frequently, accent is the right choice to enhance the focal point. Any area of your painting that you feel needs more punch is an appropriate place to place an accent. But don't get carried away. Accents and highlights are tools that must be used selectively.

Each Painting Is Unique

Remember to tailor your work for each painting. Give yourself the latitude to make necessary changes as you proceed; for example, feel free to move the focal point if it doesn't feel just right. Or, as another example, if you can't see a particular section of your painting, jump back in and change the contrast to bring out clarity and definition.

SHOW TEXTURE IN YOUR WORK

To show softness, brush the paint in a manner that creates a gradual blending from one color to another. Simply mesh the adjacent colors together. A hard edge, on the other hand, means there is a distinct difference between one value and another, giving the look of a hard edge.

Evening Light of Winter, 30″×40″ (76cm×102cm)

The View from Gassin

Step 1

Begin by indicating the major masses. This allows you to see how well the design will work on the picture plane. Remember, this is just a sketch! Notice the design is a sashaying diagonal movement, which carries off this type of wide-open, panoramic view quite well. The strong diagonal movement is stopped by another diagonal going in the opposite direction. The vertical shapes are also effectively placed to stop the eye from leaving the picture plane. Any time you have a line leading the viewer's eye out of the picture plane, counteract that movement with lines going in the opposite direction, or intersect it with a more vertical line.

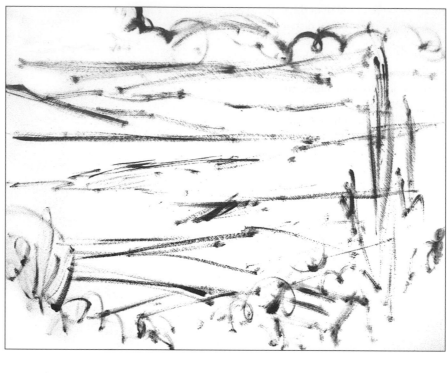

MATERIALS LIST

Cadmium Red

Cadmium Yellow Pale

Cerulean Blue

Cobalt Blue

Crimson Lake

Phthalo Blue

Titanium White

Ultramarine Blue Deep

Yellow Ochre

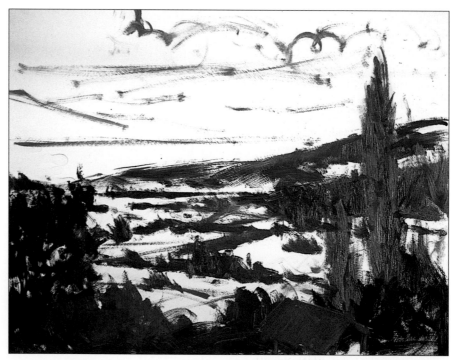

Step 2

Block in the middle to lower values of the trees and the middle ground with a mixture of Ultramarine Blue Deep, a very small amount of Cadmium Red and a touch of Cadmium Yellow Pale. You are actually mixing a violet and a yellow together for the green areas. Block in the two foreground rooftops using Cadmium Red mixed with a green composed of Ultramarine Blue Deep and a touch of Cadmium Yellow Pale.

Step 3

Block in the mountains, but keep their values light because, overall, they need to be lighter in value than the middle ground in order to show distance. Predominantly, use the blue section of your palette, Cerulean Blue, Cobalt Blue, Ultramarine Blue Deep or combinations of these colors. To these blues, add white where necessary to lighten the value, and then add Cadmium Red, Cadmium Yellow Pale or Yellow Ochre, whichever is appropriate, to create either a light violet, a soft green or light blue green. Continue to add more light to the mountains by mixing more white into your colors. Slightly increase the contrast of the light sides of the mountains, compared to the darker sides of the mountains where they turn away from the light.

Step 4

Now it's time to block in the sky. Since your light source is the sky itself, the overall value of the sky will be light in value and in direct contrast to the rest of the picture plane. Mix together Cerulean Blue and Titanium White. The lighter the value, the thicker the paint! Then add Yellow Ochre (just a little) to create a light, warm color. If your color still does not appear light and warm, start again. Remember that as you develop the value of the sky, it will be lighter the closer you get to the mountains (since you are receding into the distance).

Now, mix Ultramarine Blue Deep with a very, very small amount of Cadmium Red (the color will now take on a violet cast), and block in the shapes of the clouds. Once this is accomplished, mix Yellow Ochre (just a little) and Titanium White to create a warm, tinted white. Gradually add a little bit of this mixture to the violet clouds. Use it to show where light is hitting the clouds, and to develop stronger contrasts which indicate light direction. Make sure to keep your paint wet as you work.

Once you have placed the value of the sky, it will be easier to identify what value you should use for the water. You might try a combination Cerulean Blue and Titanium White, with a touch of Yellow Ochre.

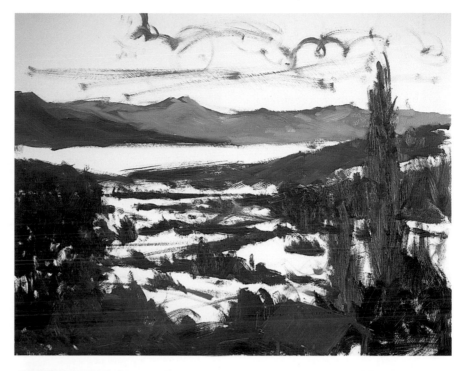

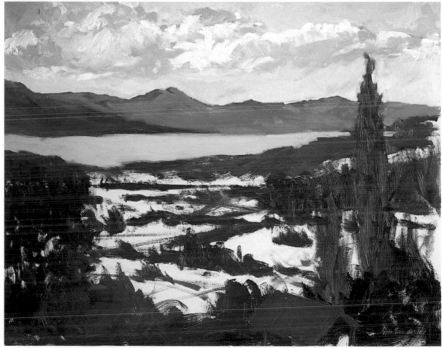

STUDY NATURE

If you use a camera to shoot reference photos, one thing to be aware of is that the camera is not as sensitive as the human eye and misses some of the slight nuances. Study nature so that you will have an understanding of the atmospheric conditions necessary to make your work believable.

Step 5

Continue to develop the light on the mountains. Where light hits the mountains, warm the color. Use a bit of Cadmium Yellow Pale and Yellow Ochre to achieve this. Mix your yellows, blues and a bit of white to create the very soft greens. If at any moment during this development you feel you have too strong of a green, add a very small amount of Cadmium Red to neutralize the color.

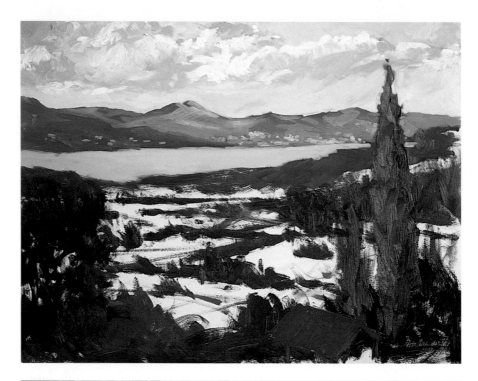

EXPERIMENT ON YOUR PALETTE

The correct place to experiment with and modify your colors is on the palette—not on your painting! By the time you work on the painting itself, you should be deliberate and precise with your color selections. That way, you will know in an instant if you have made the correct color choices. If you're not happy with your choices, go back and work with your palette as necessary.

Step 6

Block in the value of the horizontal plane (the land). Since you've already painted the sky, you can now effectively judge the correct value for the land. Contrast its values with those of both the sky and the vertical plane. Notice how the colors of the horizontal plane become more blue as they recede into the distance. So that the large area of the fields will not become boring, paint some portions with a blue green mixture, other portions with a yellow green mixture, and use a spattering of pale earth tones. To create the earth tones, mix Cadmium Red with Titanium White and Ultramarine Blue Deep with Titanium White. Then combine them and add in Cadmium Yellow Pale. For another nice earth tone, mix Cadmium Red with Titanium White and a green color mixture of Ultramarine

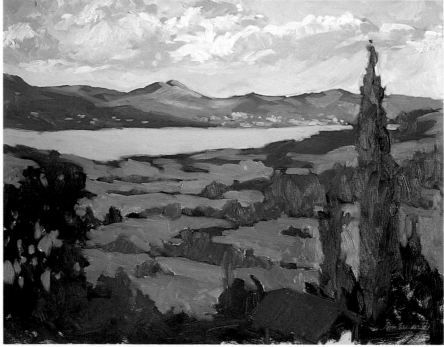

Blue Deep, Cadmium Red, Cadmium Yellow Pale and just a touch of Titanium White.

Develop the trees more fully, stressing the direction of the light. Warm up the sunlit sides of the trees to show where the light strikes them. Remember to change the temperatures as well as the values of the trees as you work.

Step 7

At this point, develop the small houses more fully by showing the direction of the light as it hits the rooftops. Lighten the appropriate values by adding Titanium White and warm them up with a touch of orange (made of Cadmium Red and Cadmium Yellow Pale).

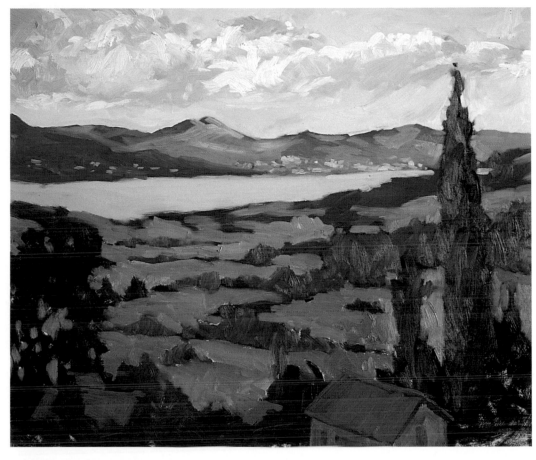

Step 8

Introduce light onto the middle-ground horizontal plane by lowering the intensity of the middle-ground colors. One way to change the intensity of a color is by adding white. To mix the right colors for any particular situation, follow this basic format. Begin your effort with a search for the correct value. Then consider the appropriate intensity, relying on the use of color complements to avoid garishness. Let value determine the intensity of the color. Then with both value and intensity in place, select the temperature, striving for just the right warmth or coolness. Painting is a constant process of juggling these variables for the task at hand.

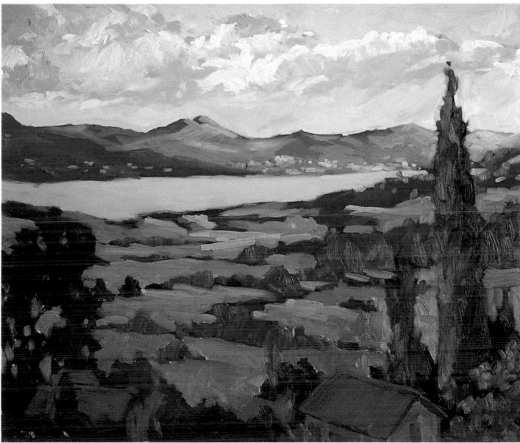

PUTTING IT ALL TOGETHER

Step 9

Place additional light values on the vertical plane. The trees in the middle ground should contrast the trees in the foreground. Notice how all the trees in the middle ground are blue green and lighter in value to give the illusion of distance. Remember that the farther away you are from an area, the less you see, since you are looking through ranges of blue atmosphere. So, do not paint what your mind knows about an area. Your field of vision has different degrees of clarity. If you see something through your peripheral vision, then paint it that way.

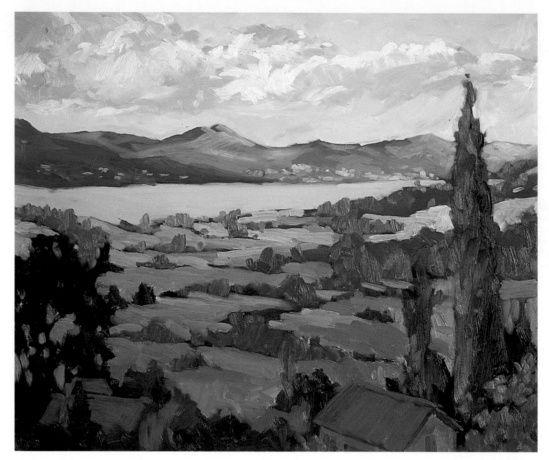

Step 10

Continue to lighten the value of the middle ground at this point, and further develop the forms of the rooftops and of the foreground trees, enhancing the direction of light as you work. As I first worked through this step, the water seemed to appear uninteresting, lacking depth, so I experimented by introducing Phthalo Blue into the background water.

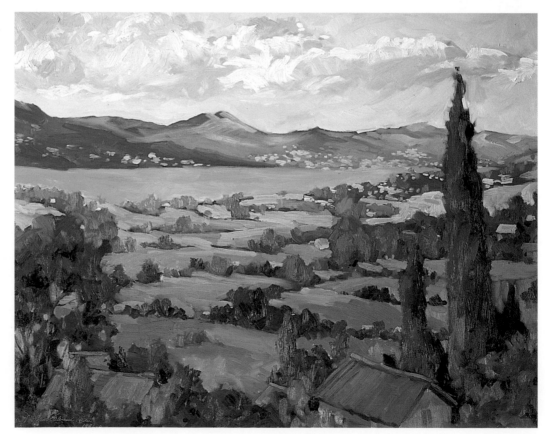

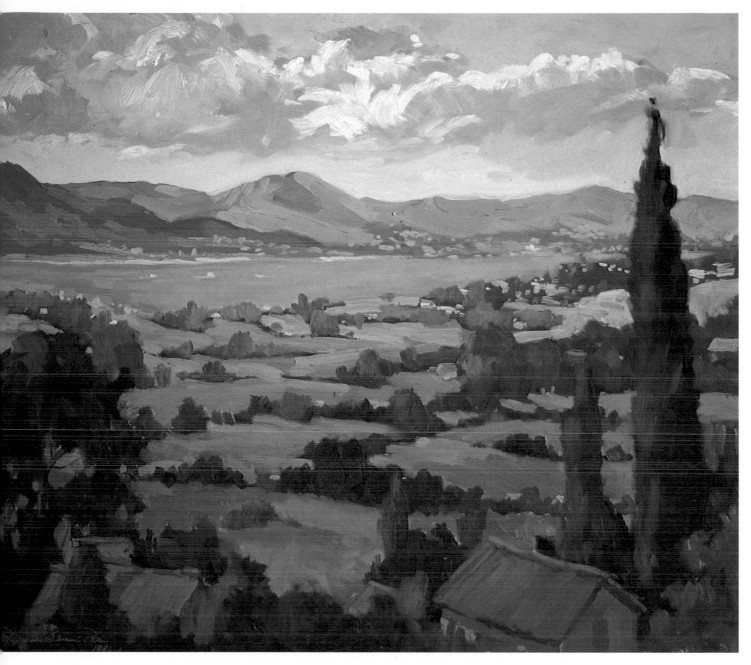

Step 11

I still felt the water lacked the illusion that I was striving for, so again I changed its color to a blue violet and added glittering lights to its surface by drybrushing a mixture of Titanium White and Yellow Ochre onto it. I added a few accents, as well as a beach to the background area. I also reworked the mountains because the one on the left was too dark in value to give as strong an illusion of distance as I was seeking. I also wished to simplify the form of the mountains because they appeared too busy.

The View From Gassin, 24″ × 30″
(61cm × 76cm)

Loch Ness, Scotland

This painting will present an interesting challenge in that the field takes up one half of the painting. So, in order to create variety, you'll need to employ several things: First, keep the value of the colors close; second, vary the edges within the mass—a slight contrast will help you achieve this effect; third, use a combination of thin and thick paint.

MATERIALS LIST
Cadmium Red
Cadmium Yellow Pale
Cerulean Blue
Crimson Lake
Titanium White
Ultramarine Blue Deep
Yellow Ochre

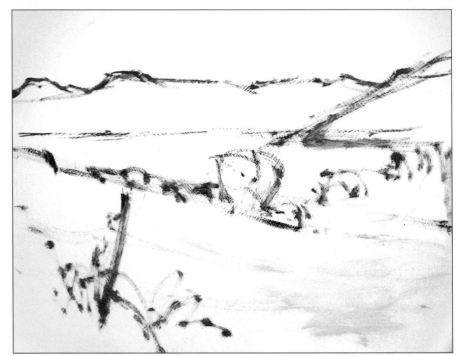

Step 1

Design your painting and sketch your major masses in Cerulean Blue.

Step 2

Use combinations of blue and yellow, blue and orange, and violet and yellow to make your various greens. Keep the value range of these various greens narrow—only about a half step apart. When you want your colors to appear as earth tones, add a minor amount of Cadmium Red. The dark green colors of the trees are made by adding just enough Cadmium Yellow Pale to a mixture of Ultramarine Blue Deep and a small amount of Cadmium Red. The more yellow that you add, the more yellow green your color will appear. If you see that you have gone too far with the yellow, just add more Ultramarine Blue. If it is still garish, add the complementary red.

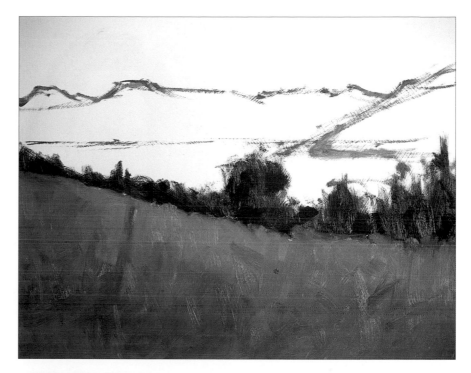

Step 3

First paint in the value of the darker mountain. Then, develop the value of the background mountain. Keep your background values much lighter than those of the middle ground. Develop some modeling in the background to show the direction of light.

At this point, stop your work on the mountains and block in the diagonal movement of the clouds. Use a combination of Ultramarine Blue Deep, Cadmium Red, Titanium White and Yellow Ochre to create a softly grayed violet to depict the dark part of the clouds. But remember that even dark clouds are just vapors and still need to give off a feeling of light coming through. Finally, paint in the value of the water, remembering that in this scene, the sky is reflected into the water.

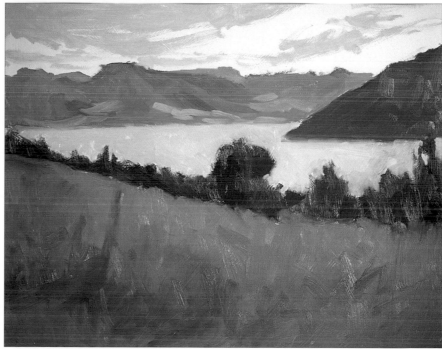

Step 4

Now brush in the light of the sky using Titanium White and a bit of Yellow Ochre. Then introduce light onto the water by using the same two colors that you used for the sky. If you remember to paint the sky in thicker paint, you'll create the illusion that the light is coming from the sky rather than from the water.

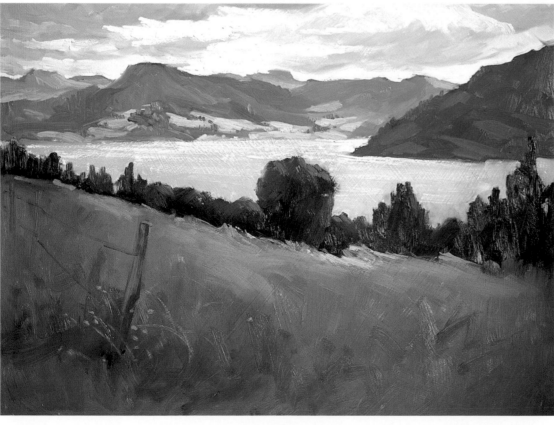

Step 5

Suggest the fence in the field. Contrast the shadow side of the post with a cooler grayed violet. Paint the slanted plane of the field more opaquely and lighter in value. Keep the colors near the center of the tree lighter in value by adding more white paint to them, which will actually make the paint more opaque.

Enhance the modeling in the background mountains, and separate the different mountain ranges from one another by changing their values. Remember that as things recede, they become lighter in value.

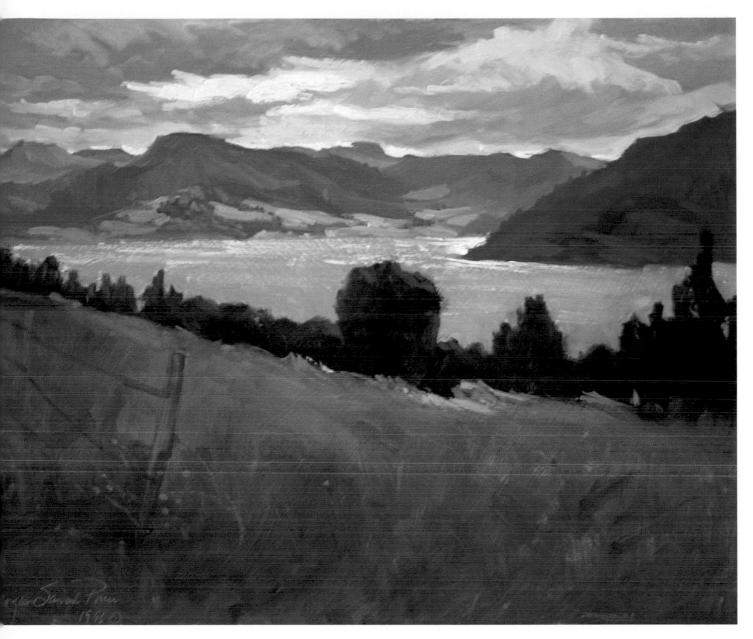

Step 6

Paint in the accents and the highlights. Make sure that the value of the fence posts is slightly darker than that of the grass. Remember that vertical planes contrast horizontal planes. Finally, double-check that the wire going from post to post is nothing more than a mere suggestion.

Loch Ness, Scotland,
16″ × 20″ (41cm × 51cm)

TIP

To make your paint appear more opaque when you are using transparent colors like Cadmium Yellow Pale, add an opaque white.

Sky in Scotland (near Nairn)

While on location in Scotland, a storm rapidly approached on the horizon. I chose to capture the moment as quickly as possible. The quick block-in method which I used comes in very handy for situations such as these. Sometimes you only have moments to capture a particular effect. And, whereas you can, and should, take your time as you learn these lessons, remember that once outdoors, speed can be of the essence. After all, that's what landscape painting is all about—the painting of ever changing atmospheric conditions.

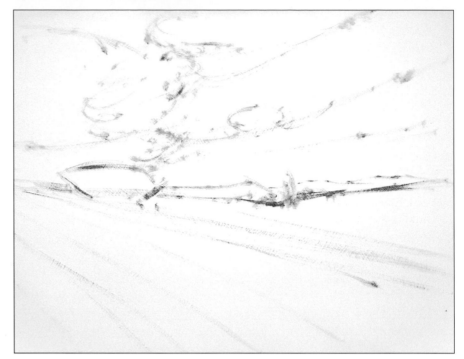

MATERIALS LIST

Cadmium Red
Cadmium Yellow Pale
Cerulean Blue
Crimson Lake
Titanium White
Ultramarine Blue Deep
Yellow Ochre

Step 1

Design your painting and sketch in the major masses with Cerulean Blue.

Step 2

Using Ultramarine Blue Deep, a touch of Cadmium Red and a touch of Cadmium Yellow Pale, paint the green grouping of trees, keeping them in the lower middle-value range. Then quickly suggest the distant mountains (the mountains are composed of Cerulean Blue, Ultramarine Blue Deep, Cadmium Red, Titanium White and Yellow Ochre).

The sky will be the most challenging part of this scene. Paint the blue sky first. Use Cerulean Blue, Titanium White and Yellow Ochre for the area close to the horizon. Add Yellow Ochre to a mixture of Ultramarine Blue Deep, Cadmium Red and Titanium White for other areas of the sky. Add more definition to the clouds by using a mixture of Titanium White warmed by Yellow Ochre to show the direction of light.

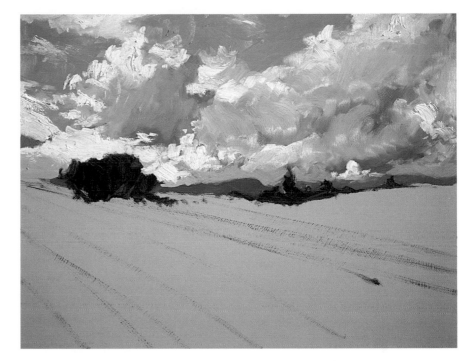

Step 3

Now brush in the water. Create the color for the water by first mixing Cerulean Blue with a bit of Titanium White. Then to that mixture add Yellow Ochre and more Titanium White. Notice how the addition of the water helps to create the illusion of more space.

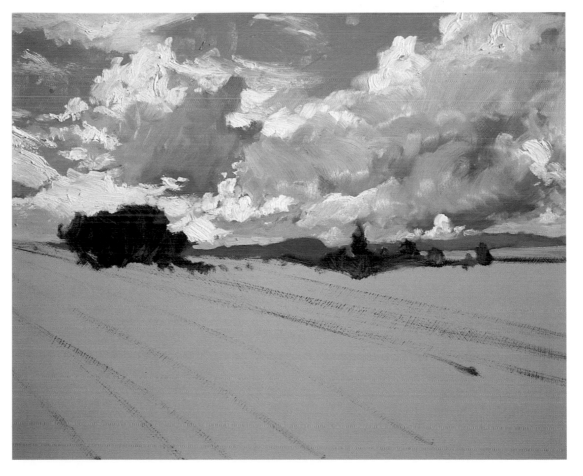

Step 4

Now address the land mass. Lay in the background using numerous combinations of green. Cerulean Blue and Yellow Ochre are one combination. Ultramarine Blue Deep, Cadmium Yellow Pale and Titanium White, neutralized by Cadmium Red is another combination. Use a mixture of Cerulean Blue and Cadmium Red to make violet, and add Cadmium Yellow Pale to it to make yet another green. The suggestion of clusters of trees and a few single trees here and there add to the variety of shapes. Suggest the rows with an earth tone made up of a combination of Ultramarine Blue Deep, Cadmium Red and Cadmium Yellow Pale.

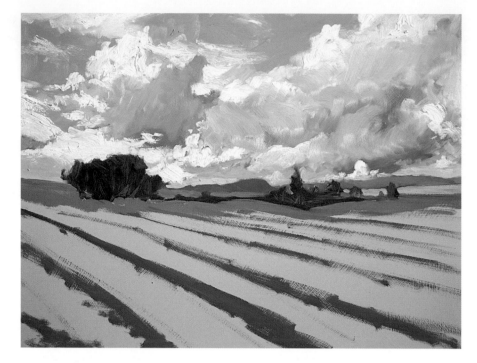

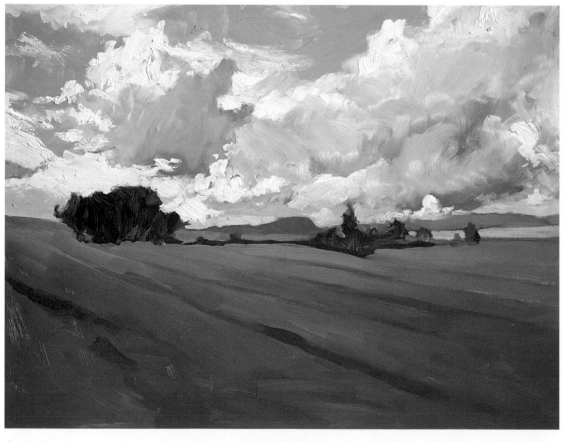

Step 5

Lay in the greens in a variety of colors. Use some of the combinations from the previous step, or create your own (infinite combinations are possible with the limited palette). Vary the brushwork, the thickness of paint and the values—slightly. The foreground should be richer in color and a little darker in value. Make sure that the foreground and background contrast each other, but keep the transition gradual.

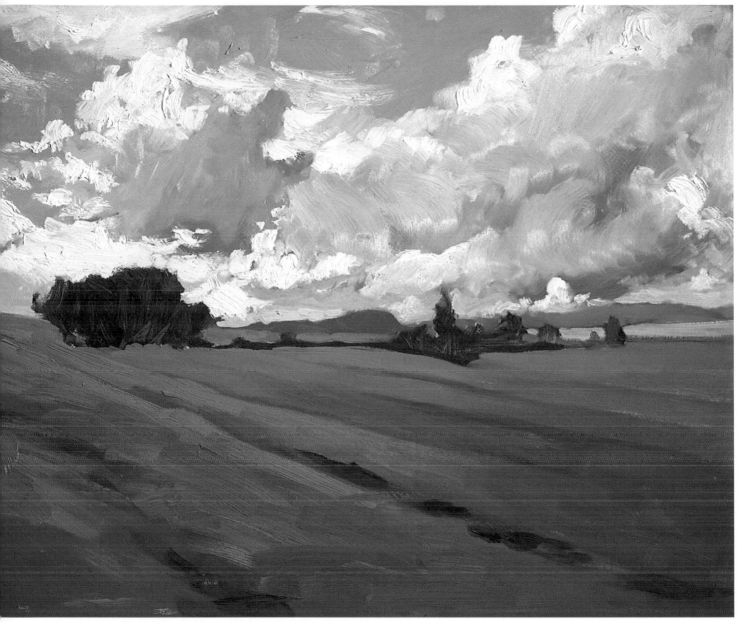

Sky in Scotland (near Nairn), 16″ × 20″ (41cm × 51cm)

Step 6

Accentuate the rows by cooling the color with Ultramarine Blue Deep and a minimal amount of Cadmium Red. Lighten the value of the grass where necessary with a lighter yellow green.

STAY AWAY FROM RIGID FORMULAS

The process of color mixing will vary from one situation to another. You will need to jockey among value, temperature and intensity to see if what you are mixing and where you are putting it is correct for the effect you want. The order in which you interplay value, temperature and intensity will not always be the same. Stay flexible, and don't get locked into rigid mixing formulas.

Spanish Wells

One major challenge, in any painting, is to create an atmospheric condition. Once you've designed your composition and drawn in the large major masses, your attention must be devoted to the conditions, to the feeling of the day. The viewer should immediately see the conditions and be able to tell immediately what season it is, what the temperature might be, and what time of day it is. But your job is not to merely copy what is before you. As an artist, you need to present in the painting the *feeling* of these conditions.

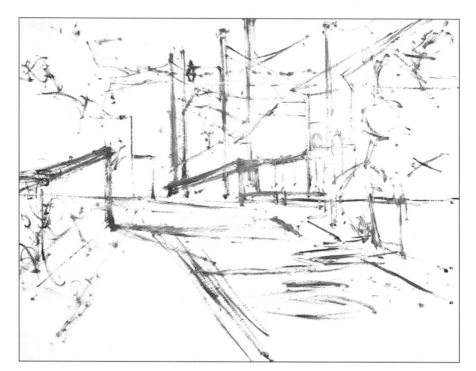

Step 1

Once again, design your painting and sketch in the major masses with Cerulean Blue.

MATERIALS LIST

Cadmium Red
Cadmium Yellow Pale
Cerulean Blue
Crimson Lake
Phthalo Green
Titanium White
Ultramarine Blue Deep
Yellow Ochre

Step 2

Lay in the darker cool greens of both the foreground and the middle ground by using mixtures of Ultramarine Blue Deep, Cadmium Red and Cadmium Yellow Pale. To get the effect of the palm and banana trees in the middle ground, use the same paint, only in a thinner application. Paint the telephone poles with the same combination of colors as well, only use more red to neutralize the color.

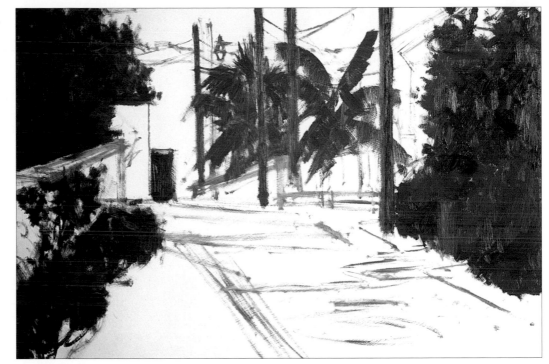

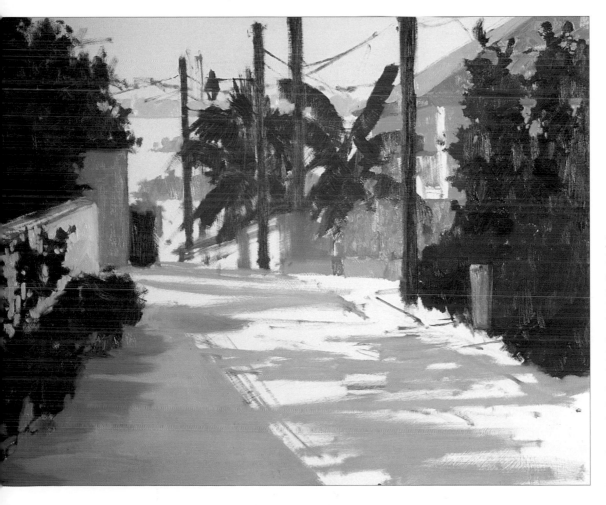

Step 3

Paint in all of the cool shadows on the horizontal and vertical surfaces by using combinations of Ultramarine Blue Deep, Cadmium Red and Yellow Ochre. Remember that the closer you are to a shadow's source, the darker that shadow's value will be. Paint in the turquoise by using a combination of Phthalo Green, Titanium White and Cadmium Red.

Step 4

Block in the sky using a mixture of Cerulean Blue, Titanium White and Yellow Ochre. Introduce a mixture of Titanium White and Yellow Ochre for the clouds. Create the water by using a mixture of Phthalo Green and Cerulean Blue, with Titanium White added to show distance. Use a bit of Yellow Ochre for the water in the foreground. Once this is done, check the contrast between the background and the middle ground, making sure that the background recedes into the distance.

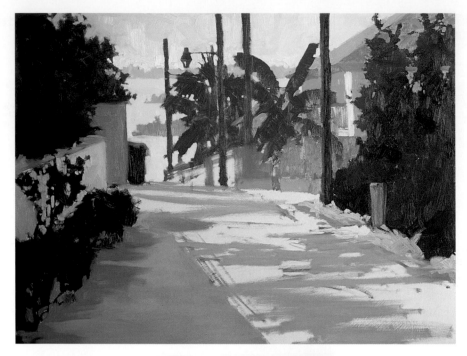

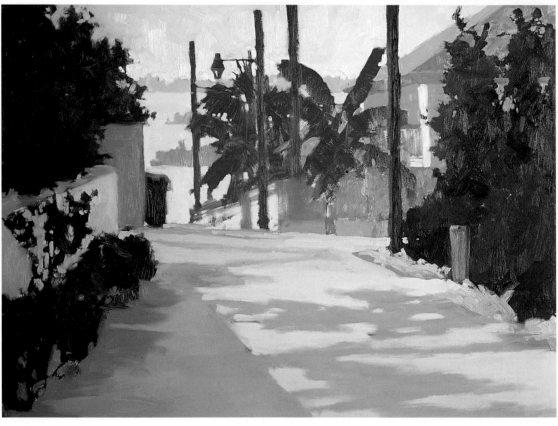

Step 5

The color for the road in the light is a combination of pinks and greens mixed with white. The light foreground area of the road will contrast with the darker background area of the road. Take particular care when addressing contrasts within the forms. Start showing form by developing the middle values, that is, by painting the lower middle ranges (the "half dark" values), and the upper middle ranges (the "half light" values). Avoid painting the darkest darks and the lightest lights. By focusing on these "half dark" and "half light" values, you set the stage for the completion of the painting.

Spanish Wells, 24″×30″ (61cm×76cm)

Step 6

Now begins the phase of adding highlights and accents throughout the painting. This is a judgment process of taking any area of the painting and "punching it up" as necessary. Each color is warmed, and the intensity is changed by the introduction of white or the color's complement (and sometimes a combination of both). Lighten the crotons with oranges and white. Make your greens from combinations of Ultramarine Blue Deep and Cadmium Yellow Pale with Titanium White and red, which are added to lighten and modify. Check all the relationships between the values to make sure that they are conveying the correct message. Sharpen or soften any edges necessary to further enhance that message.

SOFT EDGES VS. HARD EDGES

Most landscape painting is made up of soft edges. Soft edges create subtle distinctions between colors. Hard edges, however, create obvious, distinct transitions between colors.

DEMONSTRATION FIVE
Eat Your Veggies

When I first painted this piece, it went through a lot of changes as you will readily see. A "festival" look was in the back of my mind as I developed the painting, and I knew that I would need lots of intense colors and strong contrasts. The intense reds, yellows, blues and greens really brought out the festive feeling of this piece and put the whole composition in motion. This demonstration is not an exercise in subtlety!

MATERIALS LIST

Cadmium Red
Cadmium Yellow Pale
Cerulean Blue
Cobalt Blue
Crimson Lake
Titanium White
Ultramarine Blue Deep
Yellow Ochre

Step 1

Block in all the objects in the middle-value range. Use combinations of Cadmium Red and Cadmium Yellow Pale to create your oranges. When I first painted this piece, I used prepared Belgian linen, which is a more porous surface than the smoother surface I would have gotten from gesso.

Step 2

Paint the basket in colors from the yellow family mixed with violet. You can then contrast the values of these neutralized colors by introducing Titanium White into a mixture of Cadmium Yellow Pale, Yellow Ochre, Ultramarine Blue Deep and Cadmium Red. At this point, any other color that needs to be much lighter in value to show the initial contrast should be warmed with yellows, reds or oranges, and the addition of white.

The cabbage and the potatoes are the only objects for which you'll use Crimson Lake. To paint the cabbage, create a mixture of Ultramarine Blue Deep and Cadmium Red to make a deep violet, and to that add Crimson Lake. Then, if necessary, you can neutralize the mixture by adding a bit of Yellow Ochre. When you wish to lighten this color, add Titanium White, Cadmium Red and Yellow Ochre.

Step 3

Now define the different objects more fully. Each light plane of the peppers, the garlic, the potatoes and the light on the basket are warmed and lightened by adding Titanium White and Cadmium Red, Cadmium Yellow Pale and Yellow Ochre.

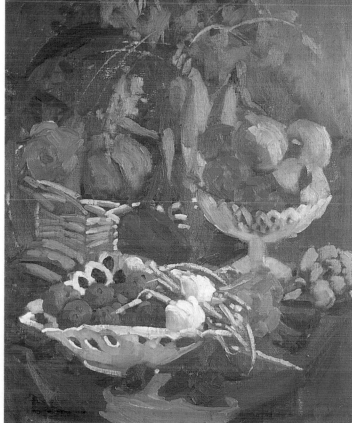

Step 4

Create the colors for the yellow bell peppers by using a combination of blue violets (made from mixtures of Ultramarine Blue Deep and Cadmium Red) and Cadmium Yellow Pale. Lighten the blue backdrop by adding Yellow Ochre and Titanium White to combinations of all the blues on your palette (Ultramarine Blue Deep, Cobalt Blue and Cerulean Blue).

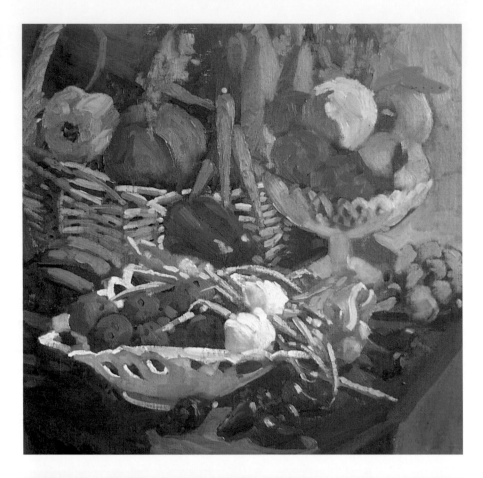

Step 5

Bring the asparagus into the light. The asparagus starts out as a violet mixture of Ultramarine Blue Deep, Cerulean Blue and Cadmium Red (add a bit of Yellow Ochre if you wish the color to be more neutralized). Then you can add Cadmium Yellow Pale to create the appearance of a yellow green.

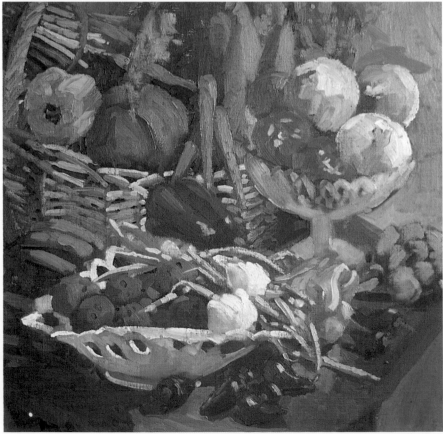

Step 6

At this point, I decided to eliminate the table from the composition because I felt that it just wasn't working. Your eyes have enough activity to take in with all the different vegetables and their containers. I felt the confusion needed to be minimized, and the best approach seemed to be to remove the tabletop.

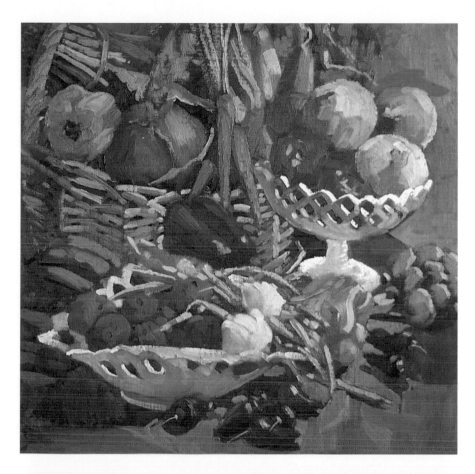

Step 7

The design was more carefully analyzed at this point. You'll notice numerous rearrangements of the tomatoes and onions in this and the succeeding steps. Anytime the design is not working, feel free to redesign! Never feel that you cannot repaint an area you do not like. Otherwise, it's like a golf game where you talk yourself out of the stroke.

I added the string beans to the lower right-hand corner to create some diagonal movement. Notice in the preceding step how all the objects on the tabletop were pointing downward to the right. By adding the string beans pointing to the left, I stopped the viewer's eye from leaving the picture plane.

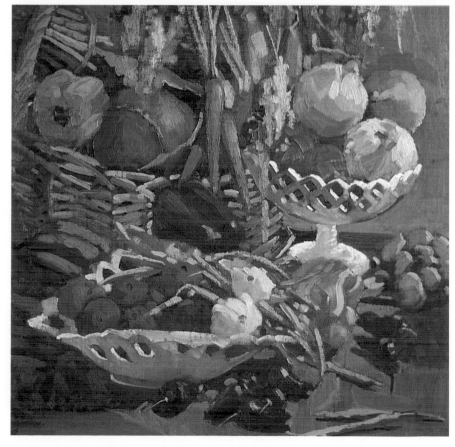

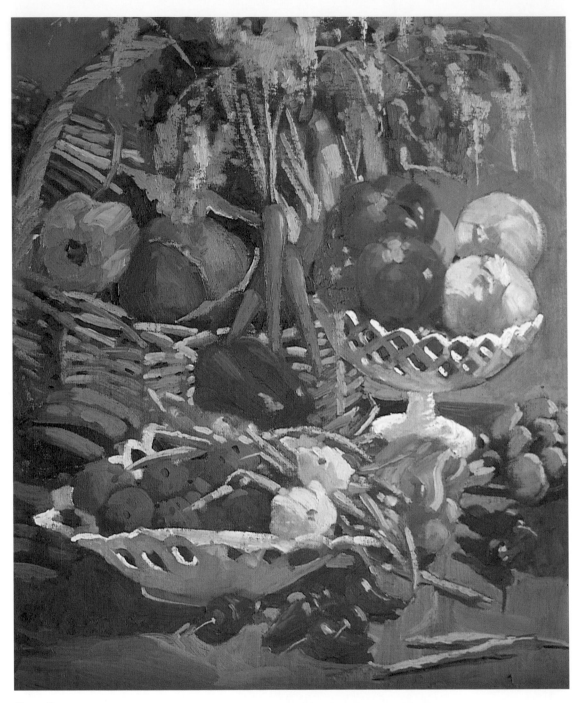

Step 8

Here I painted tomatoes over the onions because I wanted more color. I added in the accents and the highlights to punch up the contrast. And, though the design may seem close to completion, remember that it's never over until it's over.

EXPERIMENT!

Until you experiment with the colors on your palette, you will not know the color vocabulary that you have at your finger tips by mixing your colors rather than by buying tubes of violets, greens, oranges or earth tones.

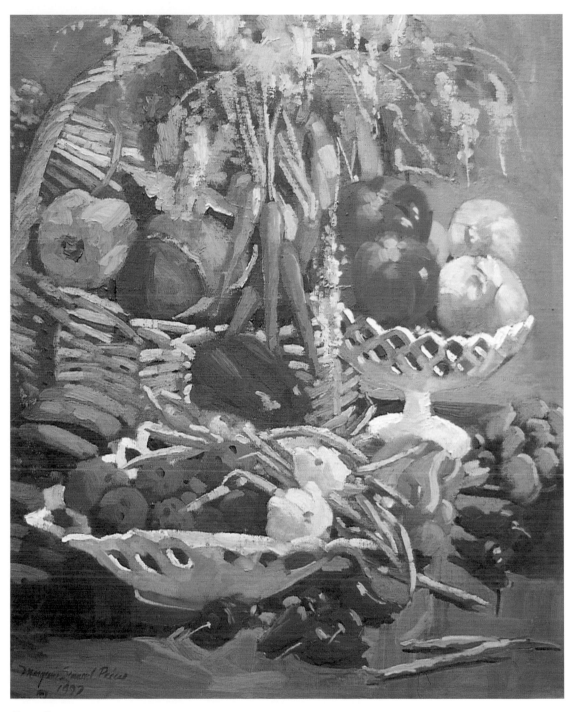

Step 9

Here I added more light into the background by adding Titanium White, Cadmium Red, and Yellow Ochre. I changed the onions one last time and added a few more carrots to improve the design. I now felt there was less competition between the onions.

Eat Your Veggies,
30" × 24" (76cm × 61cm)

Tang Elephant

This demonstration is a challenging array of textures. Between the opalescent bowl, the ceramic elephant, the geraniums and the ivy, there are plenty of problems to solve.

MATERIALS LIST
Cadmium Red
Cadmium Yellow Pale
Cerulean Blue
Crimson Lake
Titanium White
Ultramarine Blue
Yellow Ochre

Step 1

Sketch your composition in Cerulean Blue. Notice the diagonal movement of the ivy and the shadow. That movement will give you a nice lead into the picture plane and encourage the viewer to investigate the table.

Step 2

Block in all of the lighter areas with a lighter-than-usual value range. The darks in the lighter areas are about a 4 on the value scale. Add Titanium White to all the colors. The cool whites are actually a blue-gray violet tone. Later, this coolness will enable you to develop contrasts with the warmer lights (Titanium White and Yellow Ochre), and you'll end up with a nice play of warm against cool.

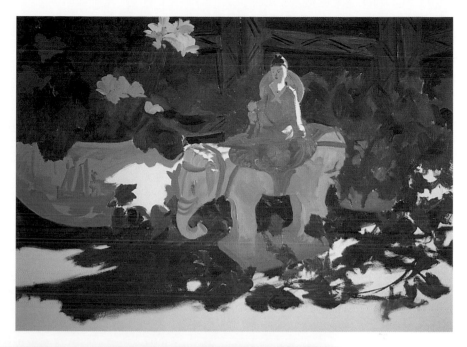

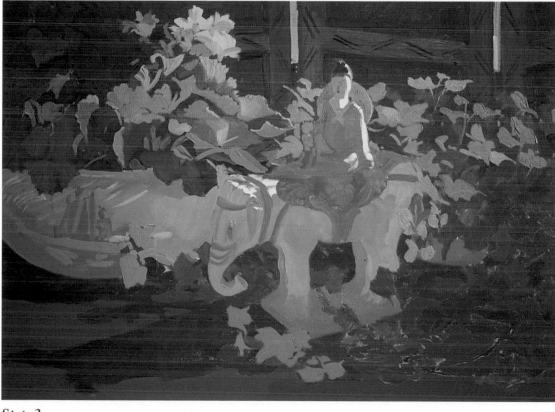

Step 3

Lay in the contrasting lights, keeping the value and the temperature of the colors clearly expressed. Use warm yellow greens for the lights, and contrast those with the cooler blue greens. In order to create more palatable greens, use their complements to slightly modify them.

Notice how your eye can move around within the painting in a playful, carefree manner. Notice also how your eye tends to pay attention to the edges of the objects within the painting and how your eye will follow the edge if there is enough variety to attract it. Variety is the key. When you become repetitious in your approach, you run the risk of boring your viewer or stopping her in her tracks altogether. Basic design flaws are generally the culprit when this happens.

Step 4

Play down the importance of the background screen by merely indicating its design—you don't want it fighting with the arrangement in front of it! Be careful not to place too much activity within the major shapes, or you can end up flattening out your painting. Generally, this happens because you put the same attention to detail throughout all of the painting—your focus becomes spread equally all over. This is a common pitfall that you'll see frequently. Avoid it! You can entertain without being Johnny-One-Note.

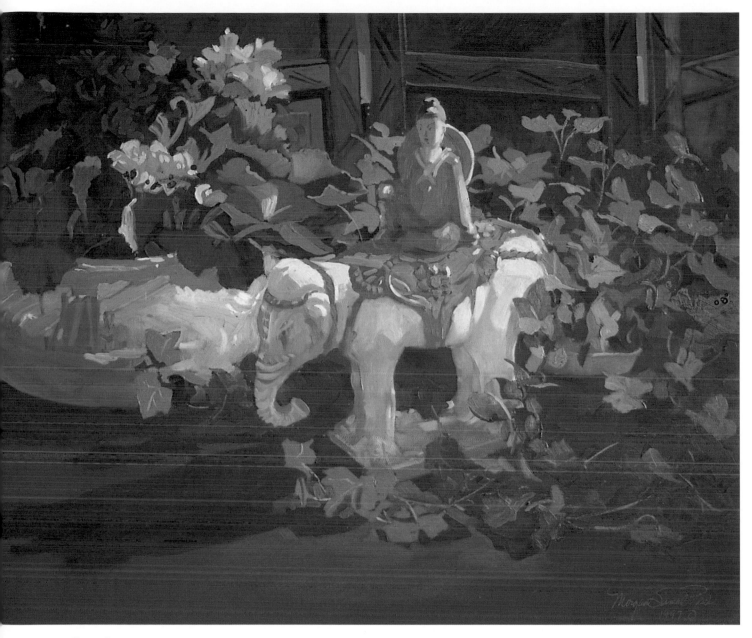

Step 5

The ivy is by far the most challenging aspect of this still life because of all the activity. Refine it, but don't paint so much detail that the ivy overwhelms the viewer's eye. What to keep and what to lose is always a juggling act. It's easy to end up with leaves competing against each other. Paint only enough to get the point across!

Further build up the little ceramic man by painting his garments in complementary colors. The yellow tunic is painted from a mixture of Yellow Ochre and violet (made by combining a higher ratio of Ultramarine Blue Deep and Cadmium Red, with a touch of Yellow Ochre).

Finally, add the accents and highlights to define the spatial feeling of the table, the negative space in floral areas and, of course, the focal point.

Tang Elephant,
24" × 30" (61cm × 76cm)

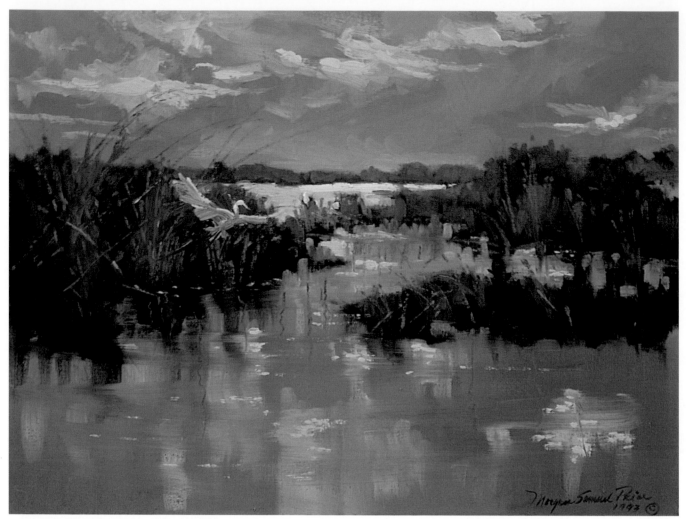

A January Day, 30″ × 40″ (76cm × 102cm)

CONCLUSION

My love of painting is in the doing. I love the thrill of delivering what I am able to see into the picture frame for others to enjoy. I paint solely because it gives me so much joy, a sense of achievement, a sense of being productive. I experience many intellectual challenges and a continuing process of discovery. What can be more fascinating than that?

But when a painting is finished, the processes of problem-solving and of making choices, the mental gymnastics around the decisions that I need to make, are over. I feel the loss of stimulation and a loss of energy. I feel let down. That's when I move on to the next painting.

I choose to paint those things that soothe and renew my spirit. I paint landscapes, for example, because I love the outdoors—that's just me. I do not choose to paint what is tragic or to paint what is historical. I leave that to others. And I never compromise my personal philosophy for the sake of the market. I feel when you paint just for the market, you are limiting yourself to someone else's opinions and preferences.

Once I frame a painting, then it's finished. Only once or twice over the years have I gone back to take something out of a frame. My belief is that before I finish what I am working on, I take it as far as my knowledge allows and then I push to be as emotionally expressive as I can be. Paint with passion! Respond to the moment with pure joy!

Do not get discouraged! You will not always work at peak form. It's just not humanly possible. Just as the best singers in the world are not always in pitch-perfect voice, the best painters cannot always hope to achieve perfection. Remember, in art, the pursuit of excellence is a long-range goal. Along the way, you will enjoy success at different levels. The important thing is to recognize and feel good about your success as you progress, even when you've accomplished only part of what you believe you

The Wheelbarrow, 16″ × 20″ (41cm × 51cm)

can accomplish. If you spend too much time and effort focusing on some particular lack of accomplishment, it may wed with frustration to knock your feet from beneath you as an artist.

Creating technical perfection is not what painting is all about. Your technical abilities—how you use color, value and design are very important, but these technical aspects should, after all, support the emotional quality of your work. Remember that the emo-

tional quality can be so strong that it can overcome your technical shortcomings. It must come first and must be apparent to the viewer. That emotional quality will give a sense of presence to your work, a feeling of "being there."

This feeling of experiencing the scene may be fleeting or lingering, but once you are able to tap into the viewer's emotions, you will have progressed well beyond technical mastery. Lasting im-

pressions are created by capturing the mood and spirit of your subject, not through a display of technical skill. Each of us has the opportunity to paint from the heart if we grant ourselves permission.

I am a firm believer in positive self-critique as an effective tool for self improvement. But don't examine only your failures; you also want to look at what you have accomplished, what works. Enjoying the occasional taste of success will provide the rein-

forcement that will help you continue.

It is important to nurture a sense of self-betterment within yourself. Many creative people are constantly competing against themselves. For some, that means placing their artwork in formal competition. And it *can* be interesting to see your work in relation to what other artists are doing. But remember that judges rely on their personal philosophies and criteria when looking at your artwork.

From my own studies and experience and from what I've learned from former instructors, remember this: Paint for yourself! Don't let anyone deter you from painting what you believe in. Listen to your inner voice, trust your instinct and go with it!

Diana's Cottage, 24" × 30" (61cm × 76cm)

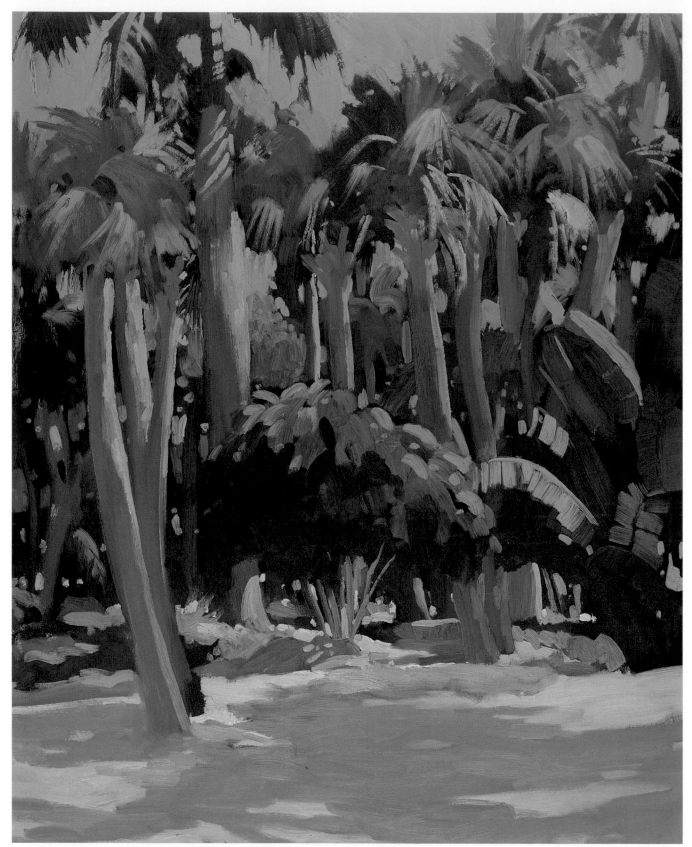

Jungle Trail IV, 30″×24″ (76cm×61cm)

Index